IMAGES
of America

AROUND TROY HILL, SPRING HILL, AND RESERVE TOWNSHIP

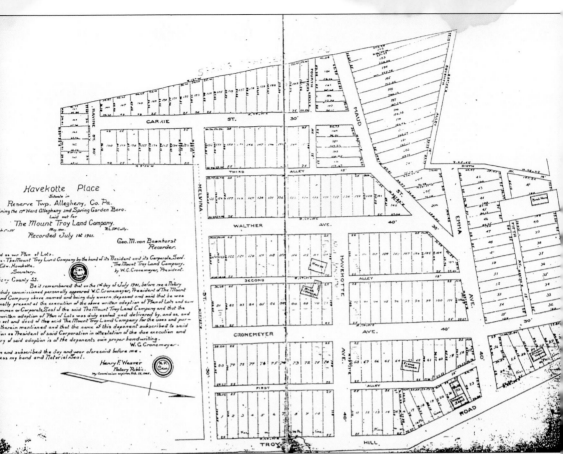

This 1901 survey shows Havekotte Place. Right around the turn of the 20th century, many prosperous residents got involved with land speculation. The Havekotte family members derived much of their wealth from their thriving jewelry business in Allegheny City. What this survey does not convey is the steepness of the terrain as the properties drop down to Spring Garden Avenue. Maud Street in the survey is to this day known as Mauch Street. Several of the streets on this map either never materialized beyond dirt roads or walking paths or they existed only on paper. (Judy Glies.)

ON THE COVER: In City View, there were no official playgrounds or schoolyards. The kids would play in the streets, especially South Side Avenue and Sunset Avenue mainly because they were wider. For football and baseball, the kids would gravitate to the City View Field. This photograph was taken in the late 1940s by the author. (Edward W. Yanosko.)

IMAGES
of America

AROUND TROY HILL, SPRING HILL, AND RESERVE TOWNSHIP

James W. Yanosko and
Edward W. Yanosko

ARCADIA
PUBLISHING

Published by Arcadia Publishing
Charleston, South Carolina

Printed in the United States of America

Library of Congress Control Number: 2011922717

For all general information, please contact Arcadia Publishing:
Telephone 843-853-2070
Fax 843-853-0044
E-mail sales@arcadiapublishing.com
For customer service and orders:
Toll-Free 1-888-313-2665

Visit us on the Internet at www.arcadiapublishing.com

To our beautiful and understanding wives, Kathy and Marianne.

CONTENTS

ACKNOWLEDGMENTS

This book sprang out of a natural curiosity I share with my father regarding history. Over the years, he has accumulated quite a collection of photographs with many dating back well into the 19th century. Some of these pictures came with stories while many were simply a conveyance back to a time before cell phones, automobiles, and televisions.

We decided to write a book.

When our editor Erin Vosgien agreed to take a chance on us, we were ecstatic and then almost immediately overwhelmed by the daunting task. We could not have completed this project without help from the following people and organizations, in no particular order: Erin Vosgien, John Canning, Bill Marks, Brittany Winkowski, Dan Kablack, Jean Koch, Miriam Meislik, Al Kaib, Frank Yochum, Ryan Taylor, Jamie McDonald, Mike Barbarino, the Most Holy Name Alumni Association, the Chapel Museum, Marge Hoffield, Dave and Marlene Dickson, Joan Russell, Kevin Kozicki, Bernie Brittner, Ted Hunkele Jr., Jeff Kumer, Pat DiGiovine, Billy Pope, Gilbert Pietrzak, the Carnegie Library, Sarah Heinz House, Bee Fohl, the Spring Hill Civic League, the Allegheny City Society, Judy Glies, Ralph Boles (deceased), Clarence Gerst (deceased), Greg Jelinek, and Daniel Mieczkowski.

One of the best things to come out of this book is the fact that I got to work on it with my father. No doubt we had our arguments during this process, but I will never forget the many laughs we shared.

Usually, these laughs involved my father "losing" vital information in one of his many folders. My mother has perfected the art of finding things where he had just looked. I also would be remiss if I failed to thank her for the many meals she prepared for me since we started on this project and for making up the spare bedroom with little notice.

Lastly, I want to thank my family for being so patient. Without the support of my beautiful wife, Kathy, I never would have been able to push through this project. I also want to thank Emma, Zane, and Seth for understanding when I had to work.

And many thanks to anyone I may have forgotten, including, but not especially, the residents of the areas covered in this book.

INTRODUCTION

A current visitor to Troy Hill would be hard pressed to imagine the woods, orchards, farms, and gardens that existed when the area was first settled back in the early days of the 19th century. After crossing Chestnut Street and walking up an ungraded road, the visitor would find themselves on a sparsely populated plateau overlooking the Allegheny River. This section of land, not quite two miles long and little more than half a mile wide, was just a tiny piece of Reserve Township. As the century progressed, more and more immigrants would come, eventually creating a unique community complete with Old World–European charm and distinct American characteristics.

In 1789, a portion of the "Reserve Tract" opposite Pittsburgh was ordered to be divided into town lots, and all of the rest of it was afterward erected into Reserve Township. This town was first called Allegheny Town and was essentially a frontier village across the river from Pittsburgh. One of the earliest immigrants to this area was Henry Rickenbach Sr., who came from the Basel Region of Switzerland in 1808. After purchasing a small piece of property along the Allegheny River, near the present location of the Sixteenth Street Bridge, he erected a log home.

Several years later, he returned to his native Switzerland and convinced family members, including Nicholas Voegtly Sr., that the economic potential of the area was strong and that they should migrate to America to build a new life. In 1823, the Voegtly and Rickenbach families purchased a sizeable piece of property from the estate of James O'Hara for $8,400, and this area became the center of the business enterprises of the families.

In 1833, these families founded a Protestant congregation officially named the German United Evangelical Congregation of Allegheny. It was more commonly referred to as the Voegtly Church. It was not long before German-speaking immigrants began to congregate in the area. They came from Alsace, Hesse-Darmstadt, Switzerland, Bavaria, and Wurtemburg. Eastern Allegheny was becoming known as Deutschtown, and the area right below what is presently Troy Hill became known as the "Swiss Hole."

The construction of the Pennsylvania Canal System along the river, combined with the commercial and manufacturing developments in the area, helped fuel a major population expansion. These early immigrants worked in cotton mills, meatpacking houses, soap- and candle-making companies, tanneries, and lumber mills. The natural progression was that the neighborhoods up beyond the flood plain began to develop. Residential enclaves in New Troy, Spring Hill, Spring Garden, and Duquesne Borough began to emerge.

Schools were opened. Churches were built. Cemeteries were expanded. People worked and people lived. They worshiped and they recreated. They sang songs in their native German tongue and they drank beer made by craftsmen imported from Europe. And they flourished.

Dirt roads got constructed where there was formerly just an Indian trail. Wood planks were laid on the side of the road for pedestrian traffic. Eventually these roads were graded. The horse-drawn cart began to move people and goods from the country to the city and vice versa with regularity.

Some roads turned into major thoroughfares, while others, because of the hilly terrain, remained steps. Along came the railroads and then even an inclined plane on East Ohio Street across from the stockyards at Herr's Island up to Troy Hill. It was not long before electric streetcars were moving people from one end of the city to the other.

In researching this book, we discovered a beautiful tapestry complete with amazing stories of triumph, industry, and sometimes hardship. One first-hand account described an incident with the *Freiheits Freund* newspaper. This was a German publication that had developed quite a circulation. One morning, about daybreak, a large block of buildings situated along the Canal caught fire and burned. The forms of the *Freiheits Freund* were just going to press when the fire broke out. They were hurriedly opened, a concise report was set up, and the paper printed. While the people of Allegheny and the South Side were wondering where the fire was, with the smoke being as bad as it was, the subscribers of *Freiheits Freund* were given news of which buildings had been affected while the flames still smoldered. No pictures of this occurrence appear in this book, but the story is just one of a thousand that will amaze the person willing to dig.

Dan Mieczkowski shared an equally amazing story about one particular Most Holy Name junior varsity basketball game from 1971. Most Holy Name was playing St. Aloysius at North Catholic High School. Games back then were played on "the stage." Dan did not get much playing time but he did have a good time sitting on the bench with his buddy Joe Spagnolo. Before each game Dan would purchase a long rod of gum from Victoria's for 5¢. Since Joe and Dan rarely got to play, they did not pay a lot of attention to the game itself.

With two seconds left in the game and with Most Holy Name sitting on a commanding lead, coach Bill Lankes called for Mieczkowski and Spagnolo to get in there. The ball came to Dan, but he had no idea what was happening. All he remembers was his teammates and the fans screaming for him to shoot. "Shoot it," they yelled. Well Dan shot it . . . and made it. The only problem was it went in the wrong basket.

Dan does not remember much about what happened immediately afterwards but he does remember his mom letting him stay home from school the next morning because he was too embarrassed. That was the only basket Dan made all season. To this day, he is not sure if it is some kind of Most Holy Name record. Once again, this is another amazing story, but there is not a single photograph to show for it.

These stories are limitless. The kindness and understanding a mother shows toward her child does not necessarily photograph well, but these stories are out there if you are willing to listen.

This is not a definitive history book. We have simply tried to capture a few moments frozen in time from a bygone era. We hope you enjoy it.

One

BRANCHING OUT FROM ALLEGHENY

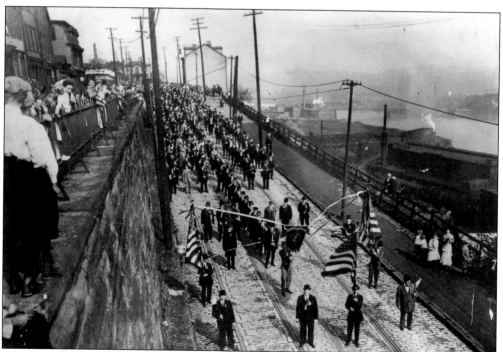

This 1915 photograph shows a procession down Troy Hill Road by one or multiple religious societies that existed at the time at Most Holy Name Parish. The wall on the left was constructed out of stones from the old Western Pennsylvania Penitentiary, which was torn down in 1886. These stones were also used for the wall on Itin Street in Spring Hill. Notice the double set of poles along Troy Hill Road. The lower set held the cables for the streetcars. Herr's Island appears off to the right just over the hill. (Most Holy Name Alumni Association.)

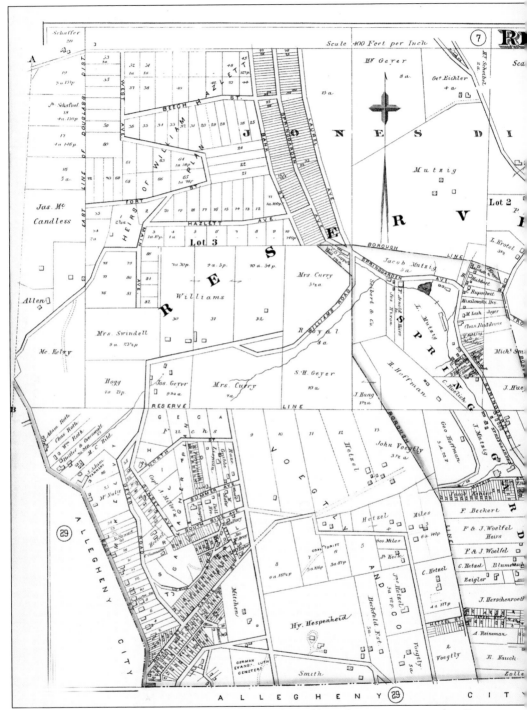

This 1886 Hopkins map, plate 8, offers a nice snapshot of how things were situated in Reserve Township in the latter half of the 19th century. Several prominent names, including Reineman, Voegtly, Hetzel, and Beckert, appear quite frequently. Large, relatively unpopulated tracts of land were held by just a few different families. In the lower portion of the map, one can see how the

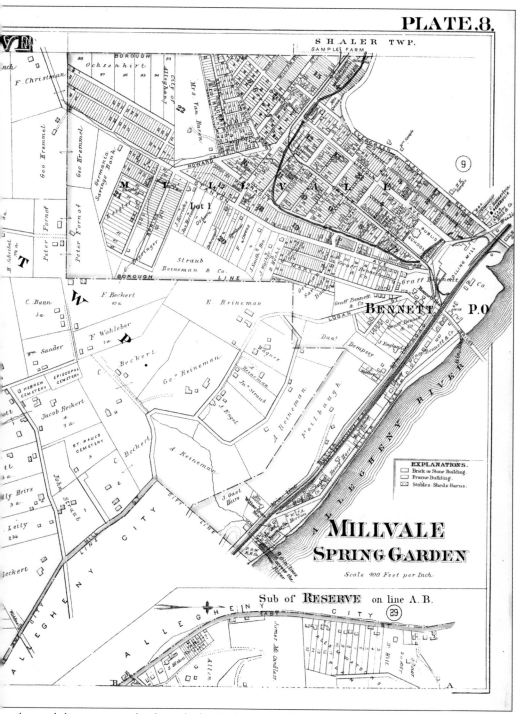

borough line comes right through the Scriba house. To this day, the house is still rather uniquely considered to be in the city of Pittsburgh as well as in Reserve Township. (G.M. Hopkins Company Maps, 1872–1940, University of Pittsburgh, Archives Service Center.)

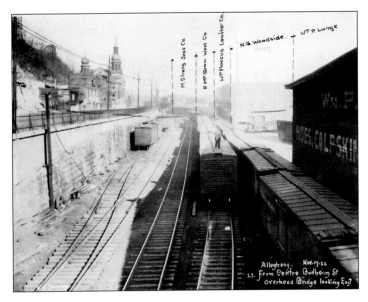

St. Nicholas Church is visible on the left at its original location on East Ohio Street in this 1922 photograph. This rail line sits where a section of the Pennsylvania canal ran through in the 1840s. In particular, one can see the several tanneries mentioned by name. These include M. Streng Sons Co., P. McGraw Wool Co., Wm. Flaccus Leather Co., N.G. Woodside, and Wm. P. Lange. (Jeff Kumer.)

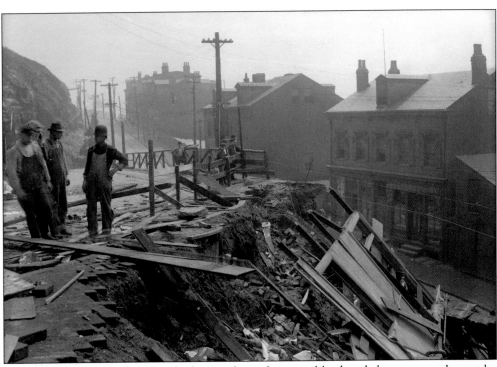

Progress necessitates change, which was clear when neighborhoods began to embrace the 20th-century conveniences of indoor plumbing, paved roads, and electricity. This 1911 photograph was taken on Province Street, located off Troy Hill Road. The Troy Hill Reservoir was located just to the left and above the men standing and surveying the building they had just demolished. (Pittsburgh City Photographer, 1901–2000, AIS.1971.05, Archives Service Center, University of Pittsburgh.)

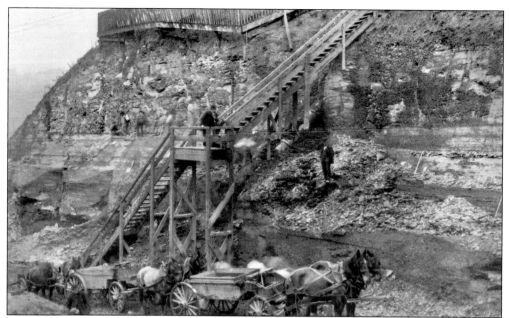

This May 5, 1908, photograph was taken on Homer Street. Prior to annexation by the city of Pittsburgh, it was called Humboldt Street. These men were working on a sewer pipe that ran down the hill underneath the Diana Street steps. These steps served the people who lived on Hill, Itin, Iona, and Catawba Streets, as well as Ives Alley. (Pittsburgh City Photographer, 1901–2000, AIS.1971.05, Archives Service Center, University of Pittsburgh.)

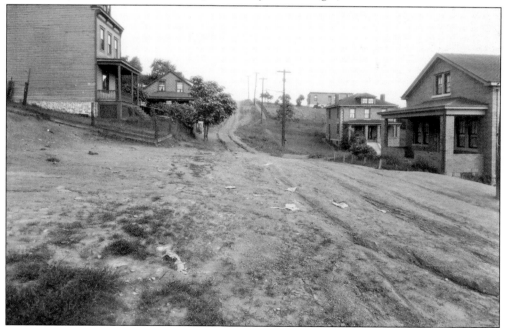

This 1927 photograph shows an unpaved Harbor Street on Spring Hill. In later years, some of the nicer homes built in the neighborhood were located on this street, which was where many kids growing up in the area hoped to live someday. Harbor Street runs parallel to and is east of Rockledge Street. (Edward W. Yanosko.)

This photograph was taken at the top of Lonsdale Street. The cemetery in the background was affiliated with the Christ Episcopal Church of Allegheny. The land was provided by Thomas and Susan Lonsdale to be used as a burial ground for, among other factors, "any persons who shall have been born in England." When the Mount Troy Volunteer Firehall was constructed in 1957, these gravesites and tombstone markers were moved. Lonsdale also sold the adjacent property for $300 to the Bes Almen Society for use as the first Jewish cemetery in the region. (Marlene Dickson.)

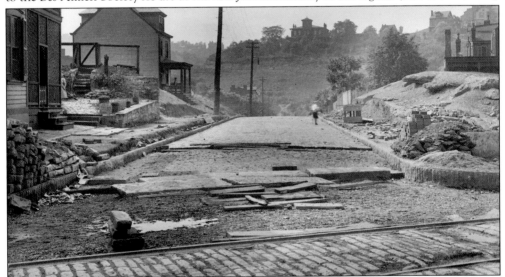

This picture was taken on Ley Street and the top of Cowley Street. Notice the trolley tracks in the foreground. These were from a line that ran from Troy Hill and continued out Mount Troy Road. The trolley line was only in operation a short period of time. Also, note the Scriba mansion against the horizon in the middle of the picture. (Pittsburgh City Photographer, 1901–2000, AIS.1971.05, Archives Service Center, University of Pittsburgh.)

As the residents of Allegheny City and Pittsburgh pushed north, the East Street Valley became an obvious artery away from the city and out to the country. In this undated photograph are East Street and Howard Street, which ran parallel to each other. Eventually, the suburban residents needed an expressway back into the city, and the valley became an obvious choice for a new highway. After decades of legal wrangling and citizen protests, Interstate 279 was completed in 1989. While the homes and businesses have been long torn down, the memories of the residents will endure. (Kate Leitsch.)

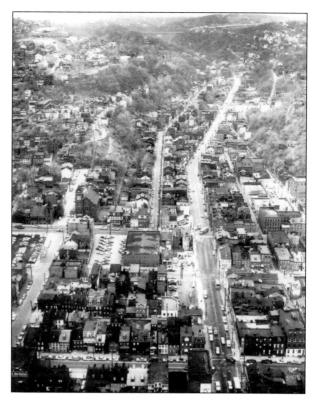

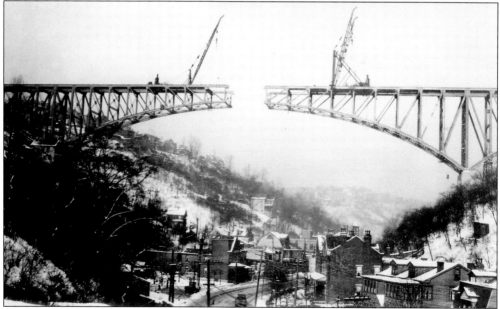

The E.H. Swindell Bridge connecting Charles Street on the west and Essen Street on the east was completed in 1930. It is more commonly known as the East Street Bridge. Pennsylvania's highway builders spent more than two decades putting an expressway through this valley, most of it involving right-of-way acquisition. Interstate 279 was completed in 1989, and the landscape below the bridge was forever altered. (Carnegie Library.)

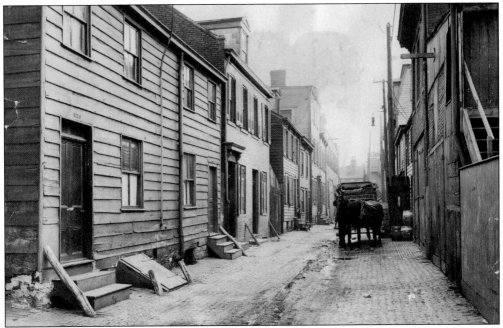

This picture of Gerst Way was taken in the 1920s. It was located between Madison Avenue and East Street. A short section of this alley was at one time situated on the west bank of Butchers Run. After annexation, it became a part of the 23rd Ward of the North Side. This area was a mixture of residential and commercial properties. (Edward W. Yanosko.)

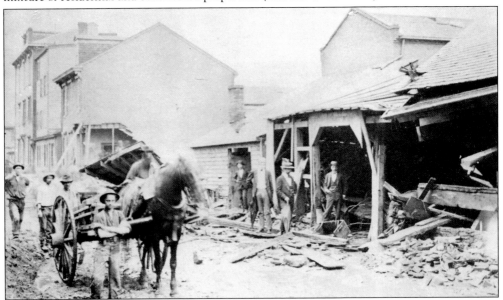

Pittsburgh and Allegheny City have always been prone to flooding, but prior to the development of the East Street Valley, one of the more troublesome streams was Butchers Run. On July 26, 1874, after a torrential downpour, a raging flood developed and a wall of water crashed through the steep valleys and ravines, carrying buildings, livestock, mud, furniture, and bodies. Over 200 lives were lost in the disaster. This photograph shows the cleanup that took place on O'Hara Street, now known as Spring Garden Avenue. (Carnegie Library.)

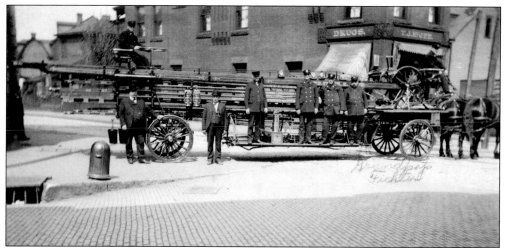

Engine Company No. 11 was located at Branch and Forest Streets. This intersection is now known as Ley and Froman Streets. Notice the "garbage can–like" covers that were placed over the fire hydrants back then. In 2001, at the suggestion of Capt. Donald Dorsey, Mary Wohleber was successful in having the Joseph Stillburg–designed building designated as a historic landmark by the Pittsburgh History & Landmarks Foundation. A firehouse had been located at this site from the 1850s until it was closed, against the wishes of the citizens, in 2005. (Frank Yochum.)

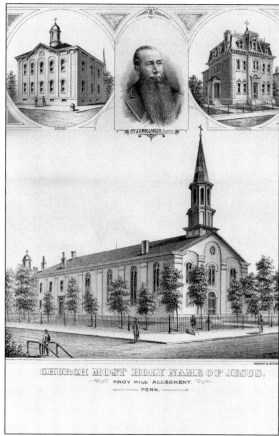

This undated lithograph print shows a young Father Mollinger surrounded by the structures he helped build for the recently formed parish. Not included in this print was his crowning achievement, namely St. Anthony's Chapel, which began construction in the early 1880s. Father Mollinger studied medicine in Europe before immigrating to America. His family's wealth enabled him to construct some amazing buildings at a time when his new parish was just starting out. (Most Holy Name Alumni Association.)

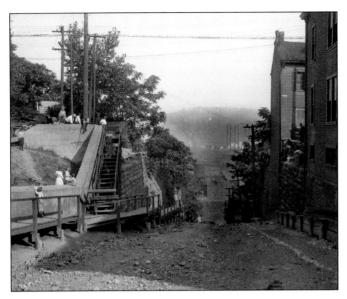

This picture from August 31, 1915, was taken from the top of Ravine Street. This steep street was also widely known as Pig Hill or Pig Alley. It received this name because pigs were herded up the street from the stockyards on Herr's Island. They were marched up at night through part of Troy Hill and then down Wicklines Lane to Spring Garden, where they were processed at various slaughterhouses. (Pittsburgh City Photographer, 1901–2000, AIS.1971.05, Archives Service Center, University of Pittsburgh.)

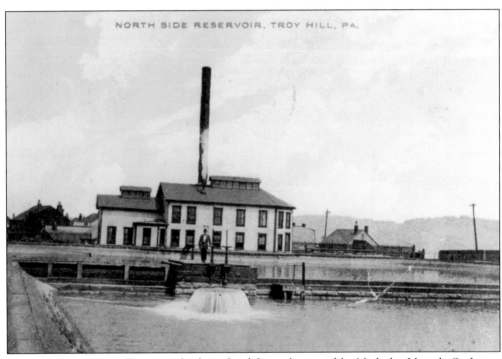

The Allegheny Water Basin was built on land formerly owned by Nicholas Voegtly Sr. It was sold to the Allegheny City Committee in 1847 for $12,000. The reservoir was built the following year. Easily obtaining fresh water was a constant problem for urban areas in the 19th century, and Allegheny City was no exception. The water was pumped 570 feet up the hill from the river. After filtration in the reservoir, the water was sent back down to the homes and businesses in the area. (Edward W. Yanosko.)

This artist's rendering shows the Troy Hill Incline, which was operational from 1888 to 1898. This was the first incline to be utilized in the hills around Deutschtown. It ran from a spot on East Ohio Street up to Lowrie Street on Troy Hill. It measured 410 feet long with a height of 270 feet. It carried freight as well as passengers. At the time of its construction, there were approximately 3,000 people living on Troy Hill. The cost of construction for the incline was approximately $94,000. (Illustration by Ryan Taylor.)

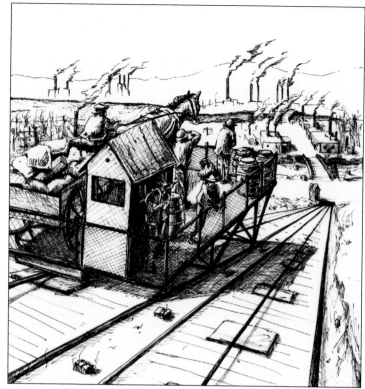

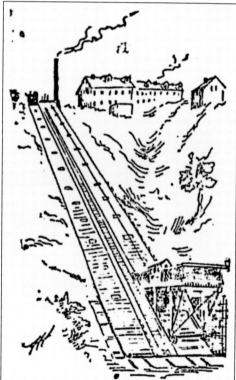

On the occasion of the opening of the Troy Hill Incline in June 1888, the *Pittsburgh Press* ran a front-page story with an accompanying sketch. The architect, Gustav Liudenthal, explained the benefits of the new structure. A 250-horsepower engine drew the steel cables up the inclined plane, and according to the reporter, arrangements had been made for using either natural gas or coal for fuel, as may seem most expedient. After the incline fell into disrepair, a decade later, it closed and never reopened. (*Pittsburgh Press.*)

This photograph from the 1940s shows a bit of what the conditions were like on the Howard Street Extension. The extension ran from Elmira Street to Suffolk Street. At the time this photograph was taken, this section was an unpaved road. This area is just about directly across from where St. Boniface still stands. (Edward W. Yanosko.)

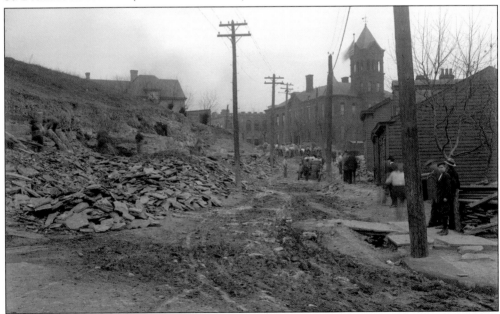

This photograph was taken on Damas Street in Spring Hill on April 12, 1912. It shows some of the men doing the backbreaking work using picks and shovels. The men cut into the hill so the road bed could be widened. Notice the horse-drawn wagon between the utility poles and how narrow the street was at the time. The Spring Hill School with the 1908 addition is on the right. (Pittsburgh City Photographer, 1901–2000, AIS.1971.05, Archives Service Center, University of Pittsburgh.)

August Hartje was born in the Kingdom of Hanover in 1826. He came to Allegheny City with his parents in 1835. He was an avid entrepreneur and invested in the Pennsylvania Oil Rush in the 1850s and the paper manufacturing business in the 1860s. August and Henrietta Goehring Hartje lived in the mansion (below) at the corner of Rhine and Haslage Streets on Spring Hill. Two of their daughters married sons of Adam and Elizabeth Reineman in this magnificent home. Emma Hartje married Augustus Reineman and Caroline Hartje married Adolph William Reineman. In later years, this property came to be known as the Schenkel Property and was eventually purchased by St. Ambrose Parish. St. Ambrose Manor, a senior citizen facility, now occupies the area. (WPHS Library.)

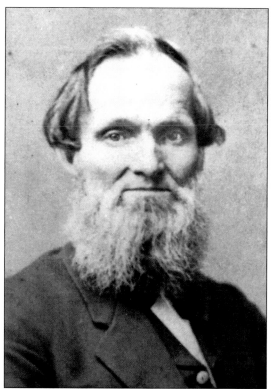

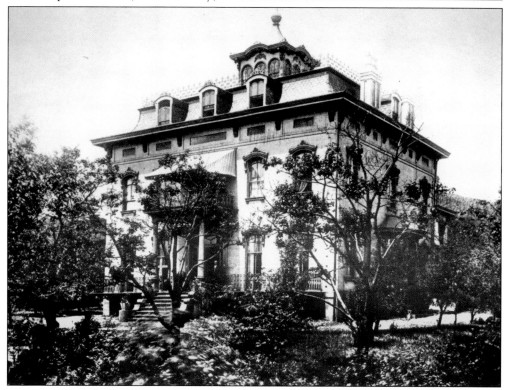

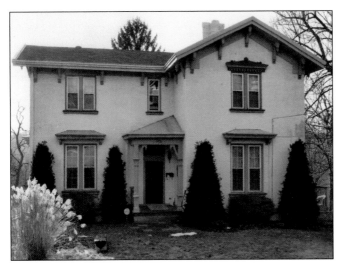

Father Mollinger, the pastor of Most Holy Name Parish, lived in this house on Mount Troy Road for just a few years during the time when the rectory was being constructed. The home sits on one of the initial bluffs just above Troy Hill; in the 1870s when Father Mollinger resided here, this home would very much have been considered a country estate complete with a carriage house. The house was sold to Jacob Mott in 1878. (James W. Yanosko.)

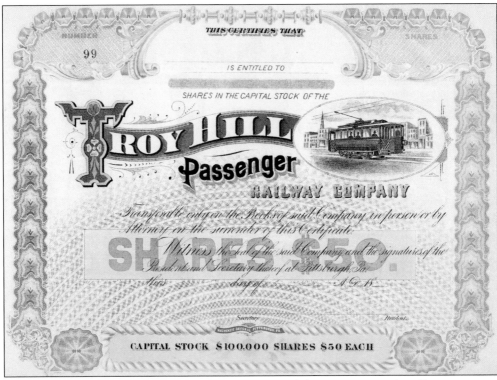

The Troy Hill Passenger Railway Company was one of the many regional trolley companies that flourished in the 1890s. Speculators drove the marketplace and, in turn, created a constant atmosphere of new companies being created and old ones being consolidated. According to *American Street Railway Investments*, published in 1898, the Troy Hill Passenger Railway Company was consolidated by the Federal Street and Pleasant Valley Passenger Railway Company that year. (James W. Yanosko.)

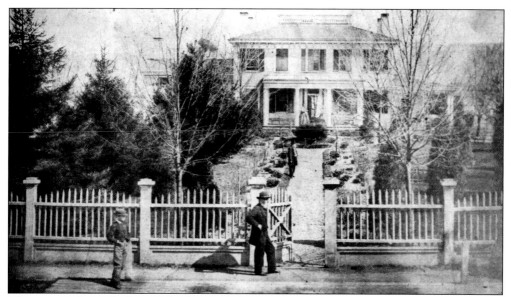

This picture shows the house of Adam and Elizabeth Reineman as it looked in 1864. This Greek Revival–style house was located along Lowrie Street. The Reinemans lived here from 1864 to 1876. The house was moved to a new site a short distance away in order for a new home on a grander scale to be built. (WPHS Library.)

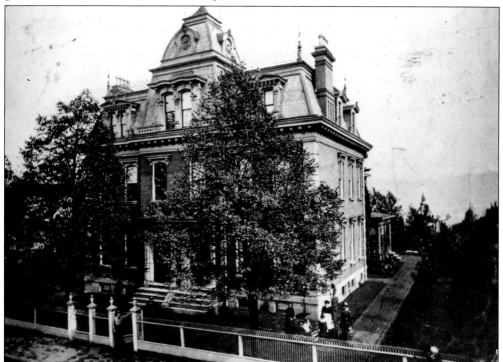

Adam Reineman built this larger Second Empire–style home in 1876. Adam and Elizabeth Reineman lived in one half with their children, while their eldest son, Augustus Reineman, and his young bride, Emma Hartje Reineman, occupied the other side. After the death of Adam Reineman, the family moved to the more fashionable Shadyside section of Pittsburgh. (WPHS Library.)

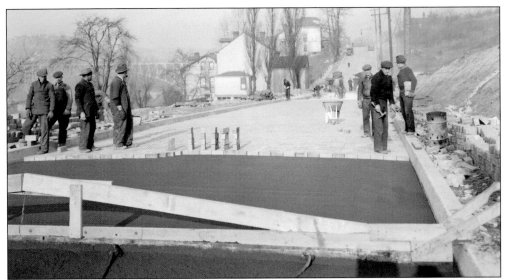

This 1937 photograph shows a group of men setting the paving bricks in a bituminous base on Sunset Avenue. As the wooden screed was pulled across the base, a smooth surface was formed complete with a crown to ensure proper drainage. Similar methods are still employed today. Notice the East Street Bridge in the background on the left. (Pittsburgh City Photographer, 1901–2000, AIS.1971.05, Archives Service Center, University of Pittsburgh.)

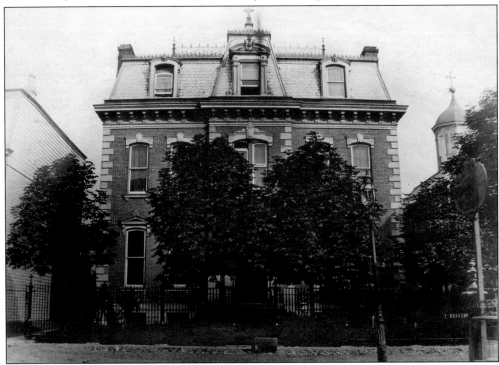

The Most Holy Name rectory was constructed in 1877. Father Mollinger paid for the massive Second Empire structure with his own family money. The building still stands today and is a reminder of the wealth from whence Father Mollinger came. It stands in stark contrast to much of the surrounding neighborhood made up mainly of working-class, frame homes. (Chapel Museum.)

Two

THE GLORY YEARS

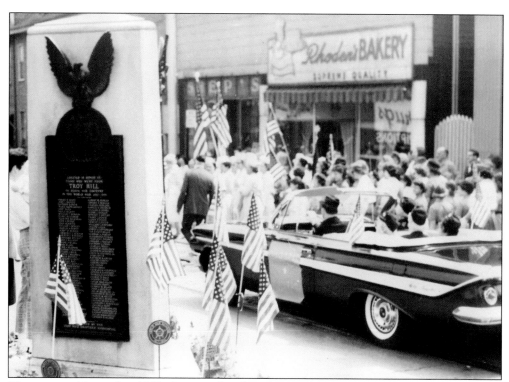

The convertible in this 1963 photograph taken during the Memorial Day parade is carrying the Gold Star Mothers. This was an organization that honored mothers who had lost sons or daughters in the war. As this was prior to the passage of the Uniform Holidays Bill, this parade took place on a Thursday. Notice Rhoden's Bakery in the background. Many will remember that on Wednesdays they offered their maple rolls two for a nickel. (VFW Post 7090.)

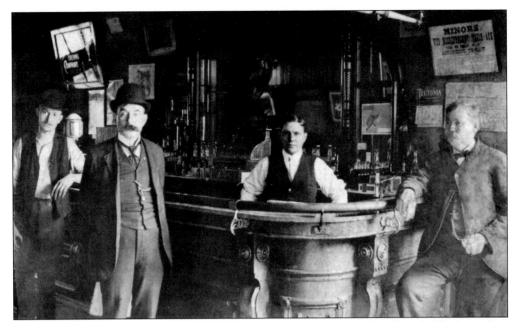

Paul Thoma, pictured at the far right, owned several saloons in Pittsburgh and Allegheny City around the turn of the century. This photograph was taken in his establishment along O'Hara Street. Notice the Teutonia Mannerchor calendar on the wall behind Thoma. The beer that was served in his tavern could have been from any one of over a dozen different brewers from the Deutschtown area. (Edward W. Yanosko.)

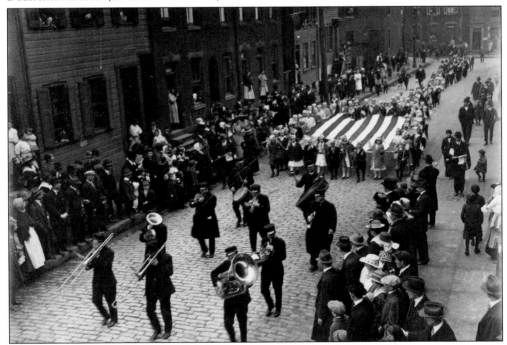

This undated photograph from the Deutschtown area is a prime example of how music and parades were an integral part of the traditions of European immigrants. Everyone stopped what they were doing and watched when the parade marched by. (Edward W. Yanosko.)

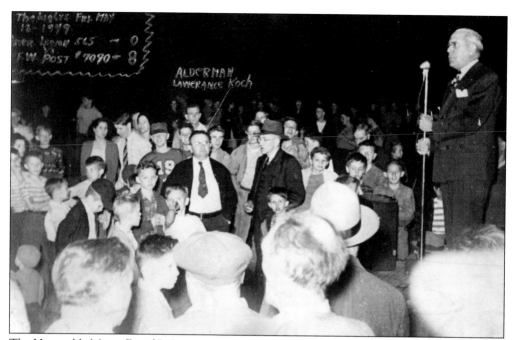

The Honorable Mayor David L. Lawrence spoke to the crowd at Gardner Field on Troy Hill in this 1949 photograph. The occasion was the first night softball game at the field. Notice Alderman Lawrence Koch in the middle of the frame. Veterans of Foreign Wars (VFW) Post 7090 defeated American Legion Post 565 by a score of 8-0. (VFW Post 7090.)

The obvious missing element of the Pittsburgh skyline in this 1958 photograph is the 64-story, 841-foot US Steel Building, which was not completed until 1970. Notice the prominent cupola on the old Eberhardt and Ober brewery in the middle of the picture. Beer production ceased at this facility in the early 1950s. (Len Mielnicki.)

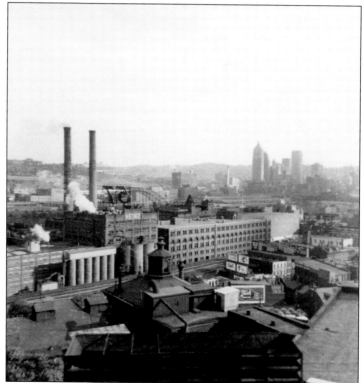

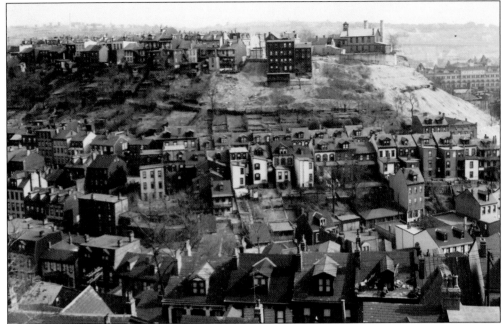

This 1952 photograph taken by Clyde Hare shows Troy Hill as seen from Spring Hill. The building in the upper right was the Troy Hill Presbyterian Church. This westernmost point of Troy Hill was home to a large Czech population at the turn of the 20th century and was known as "*Cesky Vrsek*" or "Bohemian Hill." (Carnegie Library.)

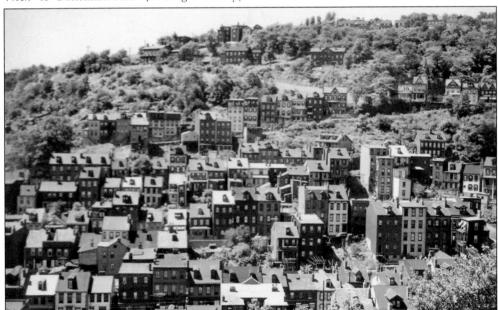

Clyde Hare probably stood on Brabec or Province Street when he snapped this photograph of Spring Hill. Goehring Street runs down the hill from left to right. Notice the Itin Street wall where it connects with Goehring Street. The stones for this wall came from the Western Pennsylvania Penitentiary when it was torn down and matched the stones that were used for the wall on Troy Hill Road. (Carnegie Library.)

The Troy Hill Nickelodeon was one of two theaters that operated on Troy Hill. Pictured from left to right are Florence O'Toole, Marie Moeller, and Catherine Schmitt. The year was 1926, and the films playing featured such stars as Herbert Rawlinson, Eva Novak, Wanda Hawley, and Sheldon Lewis. The films were still silent at this time, with the first talkie not being released until the next year. (Marlene Dickson.)

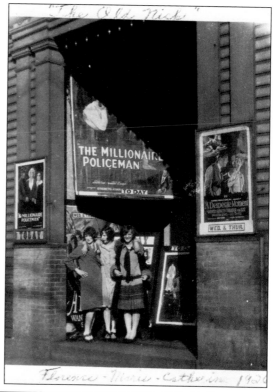

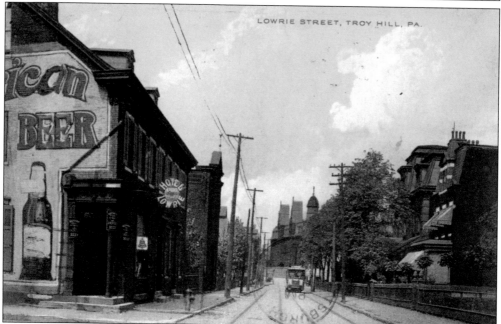

This postcard features several notable landmarks, some of which are still there today. On the right is the Adam Reineman double house where he lived with his wife, Elizabeth, and their children. In the middle is the Home of the Good Shepherd. Next to the Hotel Lowrie, the Eberhardt & Ober Brewery Stable still stands. (Mary Ann Tomasic.)

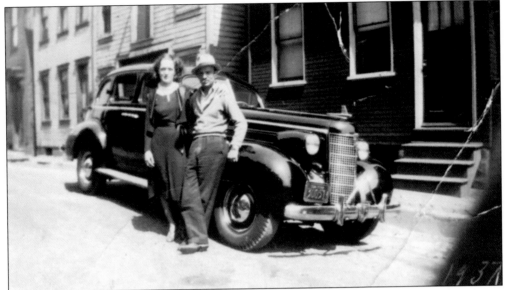

The shiny black 1936 LaSalle looks oddly out of place in this Depression-era Troy Hill scene on Elbow Street. One of the options available for this model was a heater. The cost for this upgrade was $18.50. Another option was for a clock. This would have cost the buyer $14.50. Cecilia Kunzmann and Herman Uhlig, pictured here, were dating at the time. They later married in May 1938 and had six children. (Selma Uhlig.)

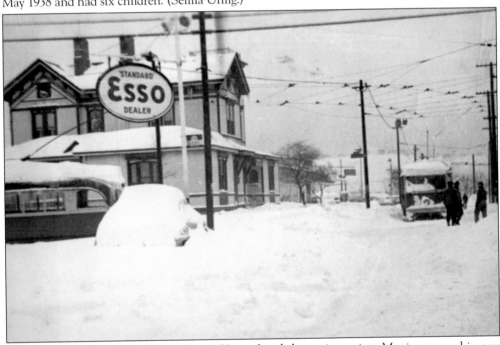

The massive snowstorm in November 1950 paralyzed the entire region. Moving around in any mode other than on foot was virtually impossible. This photograph shows a pair of streetcars that simply got stuck in the snow in front of the John Guehl Funeral Home along Lowrie Street. Brewer John Peter Ober bought this Stick-style Victorian home in the 1870s. Beyond the funeral home stood Koch's Service Station. (Dan Kablack.)

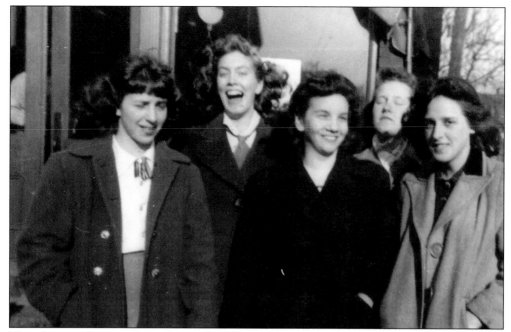

This photograph was taken in front of Greiner's Store, located at Rockledge and Damas Streets in Spring Hill. This was a popular meeting and hangout place for the local kids. Greiner's was a grocery, confectionery, and a bakery. From left to right in this 1948 photograph are Lil Mangeri, Mary Heyl, Mary Ann Urschler, Betty Velte, and Jean Fafata. (Mary Hart.)

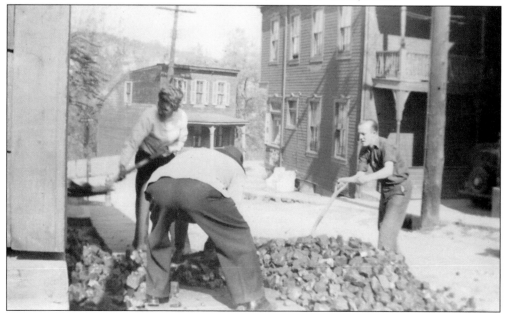

When the coal man made his delivery, the neighbors always lent a hand to get everything shoveled into the basement. Some homes were equipped with a small metal door and the coal man would use a chute where the coal could be delivered right into the basement. This 1930s photograph was taken at a property on Overbeck Street in Spring Hill. Coal was used to heat homes in Pittsburgh up through the 1950s. (James Eberz.)

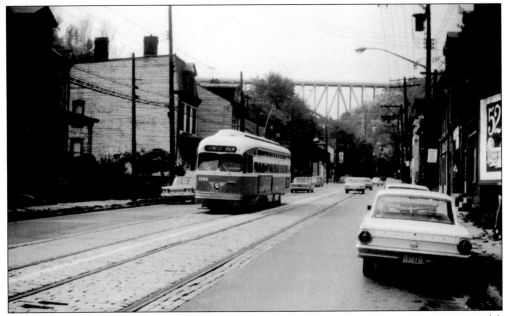

The No. 10 streetcar pictured in this 1965 photograph was a Presidents Conference Committee model. The base for the streetcar was the Keating Car Barn out by St. Benedict's on Perrysville Avenue. The cars would dip down into a wooded area right-of-way for a short section and then pop back on to Perrysville Avenue. The cars would come in East Street and then make a loop into town. This was a popular line for the local youths because it went out to West View Park. (Bob Rathke.)

Lena Ripperger is featured in this 1920s photograph of the 3200 block of East Street. The old cars pictured here were more than likely outnumbered by electric streetcars, horse-drawn wagons, and cyclists along the busy thoroughfare into the city of Pittsburgh. Just prior to annexation, this was the 14th Ward of Allegheny City, and just after annexation, it was a part of the 26th Ward. (Frank Yochum.)

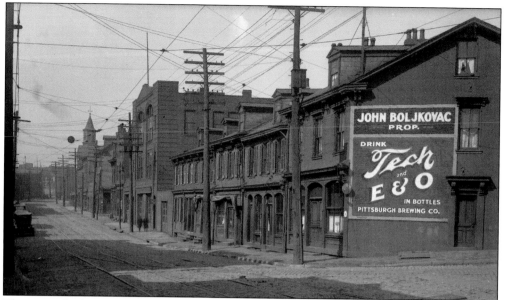

The streets look nearly deserted in this 1920 photograph of where Troy Hill Road ran into East Ohio Street. The sign advertising Tech and E&O beer is the main point of interest in this otherwise featureless cityscape. Only the choicest malts and hops were utilized. The company offered $1,000 to anyone who could discover any adulteration in its various grades of beer, according to the 1896 edition of *Allegheny County, Pennsylvania, Illustrated*. (Pittsburgh City Photographer, 1901–2000, AIS.1971.05, Archives Service Center, University of Pittsburgh.)

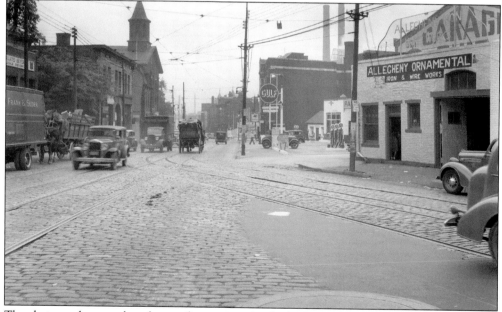

The photographer stood on the comfort station island, which used to be located at the intersection of East Ohio, Chestnut, and Lockhart Streets, and looked east toward Heinz House and the Voegtly Church. Notice the horse-drawn wagons moving along with the cars and trucks over roads that were lined with streetcar tracks. This photograph was taken August 25, 1937. (Pittsburgh City Photographer, 1901–2000, AIS.1971.05, Archives Service Center, University of Pittsburgh.)

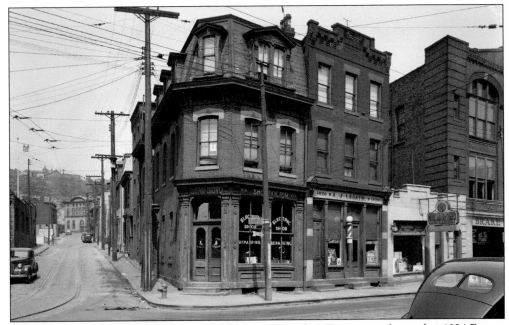

The Shoe Doctor was located at 1024 East Ohio Street. Wettach Street, named after the Gottlieb Wettach Tannery in Spring Garden, is on the left. The building at the end of the street, located on Vinial Street, is the Bohemian Hall. Above the roof, at the skyline, is the St. Ambrose Church and School on Haslage Avenue in Spring Hill. (Pittsburgh City Photographer, 1901–2000, AIS.1971.05, Archives Service Center, University of Pittsburgh.)

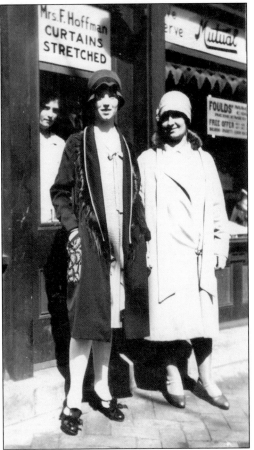

This 1928 photograph was taken in front of Francis Hoffman's store on Madison Avenue. The proprietor, shown looking out the window, sold the store in the 1940s, and the building was eventually torn down in the early 1970s to make way for the expressway. Pauline Hoffman (left) and Marie Zech (right), the future daughter-in-law of the owner, are standing outside the store. (Edward W. Yanosko.)

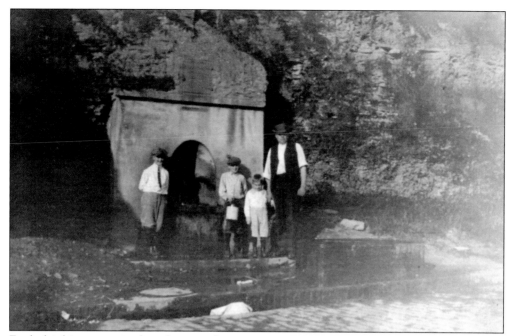

Fresh drinking water is a key element of any thriving community, and the residents of Spring Hill had a continuous supply thanks to the spring on Damas Street. Notice the water trough next to the curb where the horses could stop and get a drink. This photograph from 1927 features Fred Bergman holding his son Wilbert's hand. The other children are unidentified. This area is currently under development, and the area residents hope to one day restore this spring to its original use. (Bee Fohl.)

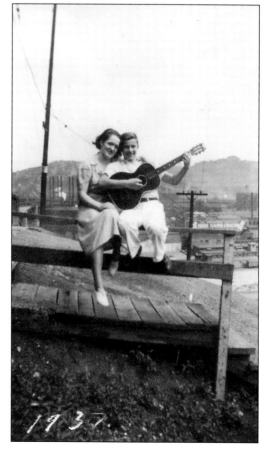

Cecilia Kunzmann and a friend are pictured enjoying the afternoon from their Elbow Street perch overlooking Herr's Island. One of the businesses visible is the Armour Packing Company, which is advertising its US government–inspected Irish hams and bacon. (Selma Uhlig.)

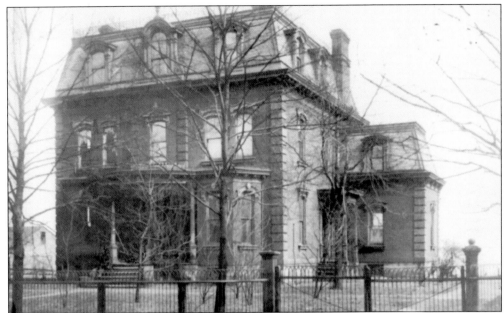

The Catholic Diocese of Pittsburgh and the Sisters of Charity of Seton Hill founded the Pittsburgh School for the Deaf in 1908. Bishop Canevin leased the "Lappe Home" on Lowrie Street, but by the end of 1909, the school on Troy Hill had outgrown its temporary home. In the spring of 1911, the school was relocated to Brookline, where it remained until 2002. It has since relocated to the Shadyside area. (DePaul School for Hearing and Speech and Allegra.)

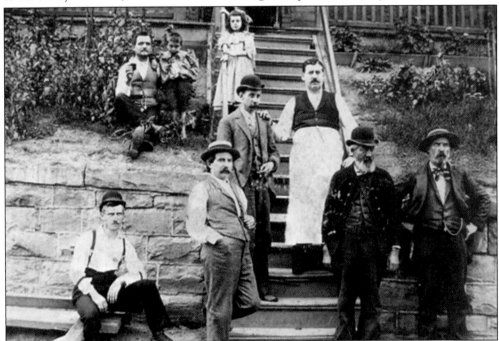

The Frank Shilling Restaurant was located on what is now Gershon Street. This photograph was taken around 1905. Local newspapers advertised the latest fashion derbies on sale at various establishments, such as Solomon's and Otto Oetting's. They ranged in price from 90¢ to $4. (Denise Haas.)

This 1910 photograph, taken from Tell Street in Troy Hill, shows several interesting features of the area leading up from Spring Garden. The paved road leading up out of the valley is Homer Street, although the photographer most certainly would have also known the street by another name. When this area was a part of Allegheny City just a few years prior, this street was called Humbolt Street. (Paul Stalter.)

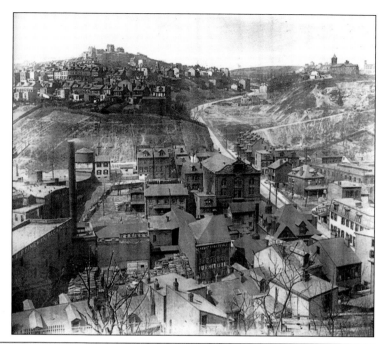

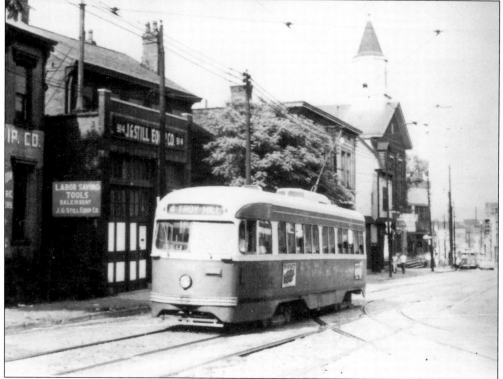

The No. 4 Troy Hill streetcar moved countless residents all over the city for several generations. This streetcar is seen making its way along East Ohio Street in 1956, with the Voegtly Church clearly visible in the background. Also in the background is the Ahlers Lumber Company. (Carnegie Library.)

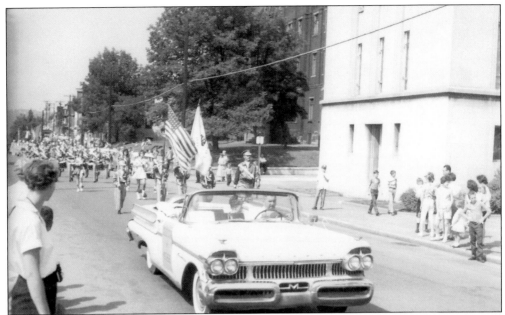

The 1957 Mercury Turnpike Cruiser carrying the Gold Star Mothers rolls along Troy Hill Road in front of North Catholic during the 1963 Memorial Day parade. Members of Post 565 proudly march behind the convertible. Notice the old structure of St. Joseph's Orphanage next to the North Catholic Annex. This section of the old facility was finally torn down that same year. (American Legion Post 565.)

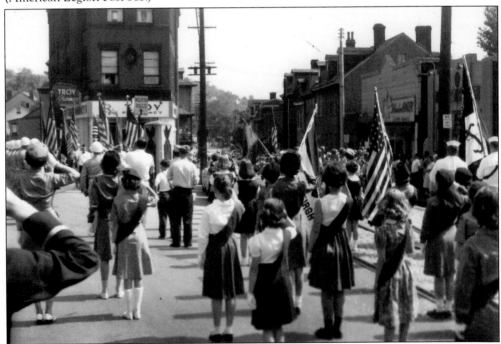

Several Troy Hill landmarks are visible in this photograph from the early 1960s. The Memorial Day Parade made a regular stop at the intersection of Lowrie and Ley Streets at the World War I Memorial before continuing down to the Voegtly Cemetery. (American Legion Post 565.)

Three

PEOPLE WHO LIVED THERE

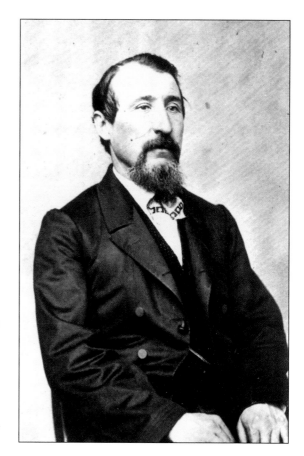

Adam Reineman, pictured here in 1857, was one of the most successful businessmen in Allegheny City. Born in Hesse-Cassel in 1820, his family immigrated to Maryland in the 1830s. He came to Allegheny City in 1843 to visit his sister Caroline and her husband, Victor Scriba, and while he was here, he met and married Elizabeth Rickenbach. He was involved with the jewelry and watch business, the family trade, as well as banking, insurance, and real estate development. He developed over 700 homes inhabited by the working-class families who lived on Troy Hill and the surrounding areas. He died in 1899. (WPHS Library.)

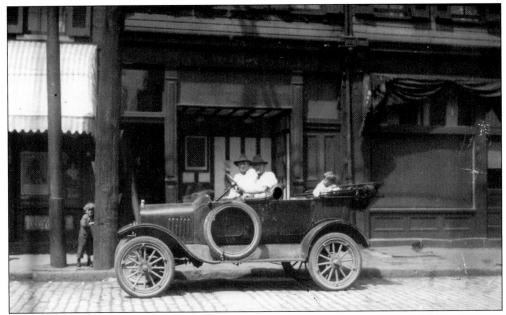

This photograph was taken on Madison Avenue in the 1920s. Notice the small child peeking out from behind the utility pole on the left. Additionally, looking closely, a Coca-Cola sign can be seen on the wall. Various neighborhood establishments offered virtually every product or service anyone would need. Cars had progressed from novelty status at this point, yet they were still far from a necessity. (Edward W. Yanosko.)

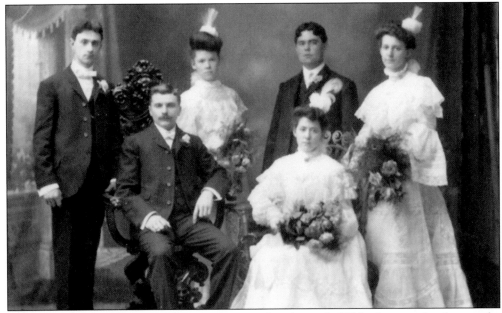

William Hoffman and Frances Thoma are pictured in this early-1900s photograph taken on the occasion of their marriage at St. Mary's Church. The couple lived in the Deutschtown area and had three children. The first child, Paul, was born in 1905. The following year the twins, Jean and Pauline, were born. Hoffman enlisted in the army at the age of 44 and was a member of the 3rd Infantry Band. He died in 1931 at the age of 57. (Marianne Yanosko.)

Pictured in 1928 are Florence O'Toole and Gilbert Kunkel wearing all the fashions typical of that era. They are posing in front of the old monument at the 2600 block of Mount Troy Road. Today, this property is used as a multiuse recreation area with basketball hoops and hockey nets. The upper portion of this property is still unofficially known as the Little Field, and kids still play baseball there. The entire property, which is known as Electric Hill, was formerly owned by the J. Voegtly heirs. (Marlene Dickson.)

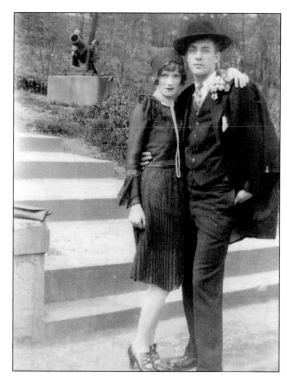

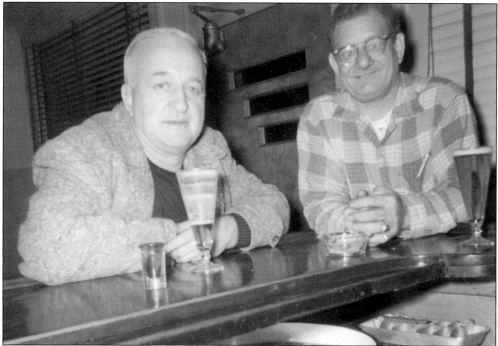

John Roch (right) was the owner of Roch's Tavern at 2501 Mount Troy Road in the 1950s. This scene of sharing a shot and a beer after a long, hard day at work was certainly replicated countless times throughout the Pittsburgh region and America in general. Notice the old-style ice cube tray with the pull handle. (Marlene Dickson.)

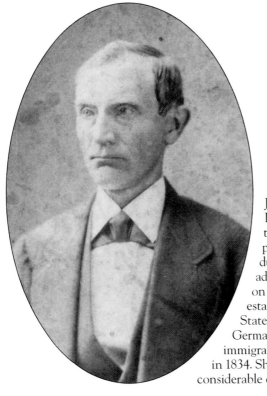

John Frederick Havekotte and his wife, Dorothea, resided in Reserve Township with their nine children. He was one of the most prominent businessmen in Allegheny City during the second half of the 19th century. In addition to being the proprietor of a jewelry store on Federal Street, he was also involved with real estate and banking. He immigrated to the United States in 1830 from an area that is in present-day Germany. She was born Dorothea Gerwig in 1822 and immigrated to the United States from Alsace-Lorraine in 1834. She died in 1880, and he passed away in 1898. A considerable estate was left behind. (Judy Glies.)

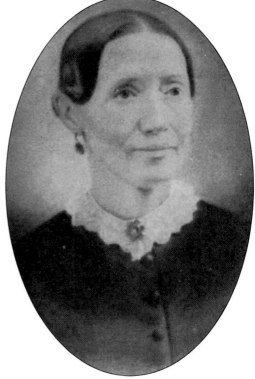

Julia Cassidy Havekotte posed for this formal portrait at the turn of the 20th century. The elaborate hat and the high collar typified the fashion of the day. She became Edward Havekotte's second wife when they were married on June 12, 1901. She died on March 26, 1939. (Judy Glies.)

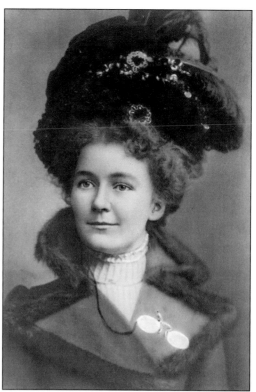

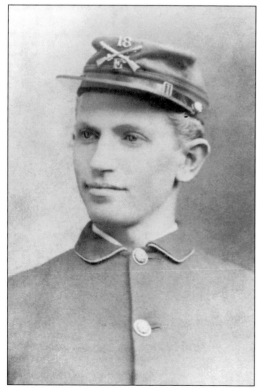

Edward Havekotte was the son of John Frederick and Dorothea Havekotte. He was born on August 19, 1857. He belonged to the Duquesne Greys and was a captain of the Old Hunt Armory in East Liberty. He was the sixth of nine children. He died in 1958 at the age of 101. (Judy Glies.)

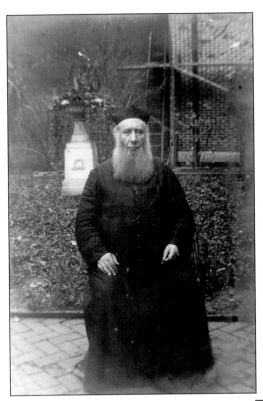

Fr. Suitbert G. Mollinger was the pastor of Most Holy Name Parish from 1868 until his death on June 15, 1892. A strongly built and imposing man at nearly six feet tall, his accomplishments equaled his physical stature. Almost immediately after arriving at his post at the new parish, he helped establish a parochial school for his parishioners. Additionally, he built a rectory and then a chapel named in honor of St. Anthony of Padua. The parish flourished under his leadership. (Most Holy Name Alumni Association.)

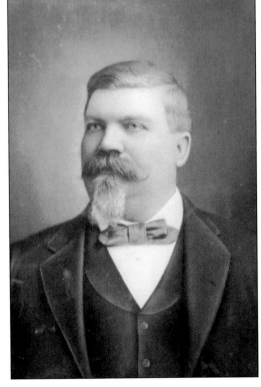

John Peter Ober was one of Deutschtown's leading businessmen. In 1870, he partnered with his brother-in-law William Eberhardt and founded the Eberhardt & Ober Brewing Company, and in 1883, they consolidated with J.N. Straub & Company. They engaged architectural and engineering firms to streamline their process, and their facility grew at a tremendous rate through 1895. They in essence turned an Old World–craft product into a commodity employing many of the same methods that H.J. Heinz was using just a few blocks away. (Penn Brewery.)

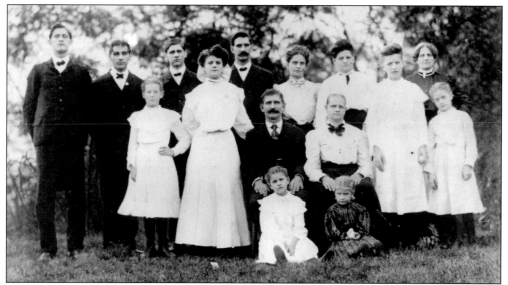

This 1902 photograph of the Brittner clan was taken on Wicklines Lane where the family lived in a rented house. Frank Brittner, the patriarch of the family, was born in Austria in 1850 and immigrated to Pittsburgh sometime in the 1870s. His wife, Caroline Krautwurm Brittner, was born in Berlin, Germany, in 1859. They are pictured here with their 13 children, from left to right, (first row) Hilda and Mable; (second row) Emma, Dora, Frank Sr., Caroline, Margaret, and Louise; (third row) Bernard, Frank Jr., Henry, Max, Ann, Bessy, and Mary. Hilda and Mable both died very young. Caroline lived to the age of 95. (Bernie Brittner.)

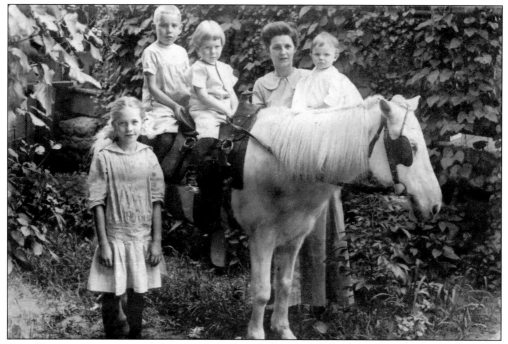

Ann Bergman is posing with her children (from left to right) Ruth, Wilbert, Lillian, and Nelda in this 1915 photograph. Photographers would walk around and have people pose on a horse or pony. Sometimes cowboy costumes would be lent to the small children. (Bee Fohl.)

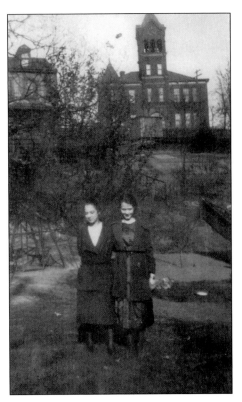

Ruth Bergman (right) and her friend Stella are pictured in this photograph from 1921. Ruth was born in 1906. The Spring Hill School and especially the clock tower are plainly visible in the background. This 19th-century structure was torn down in the 1930s. The addition, constructed in 1908, is the portion of the school that is in use today. The picture was taken in the backyard of the Bergman family residence at the top of Homer Street. (Bee Fohl.)

Mary Duermeyer is pictured along with her brothers Bobby (left) and Joe. The Duermeyer family lived in Troy Hill on Goettman Street. Mary is displaying her sophisticated smoking technique with a candy cigarette. Notice the bottles on the window sill waiting to be picked up by the milkman. (Mary Dzubinski.)

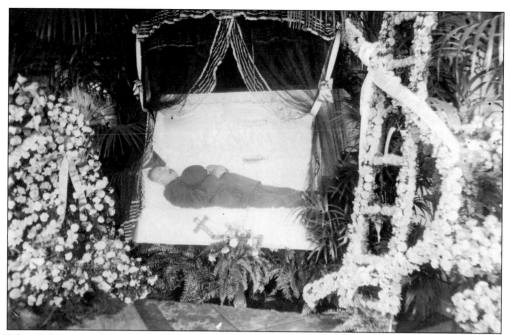

John Fichter was the captain of Engine Company No. 11 when he passed away in 1906. He was such a loved and respected pillar of the community that the only way his mourners could be accommodated was to have his viewing at the firehouse. Notice the many floral arrangements including the ladder covered with flowers. (Frank Yochum.)

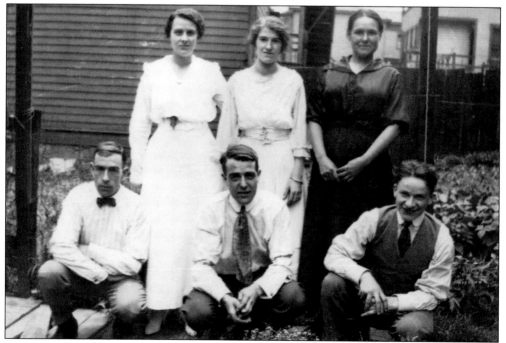

The Yochum family from South Side Avenue in City View is featured in this c. 1915 photograph. Martha Yochum, pictured standing in the middle, died during the 1918 flu epidemic. She was born in 1893, married in 1915, and died just a few short years later. (Frank Yochum.)

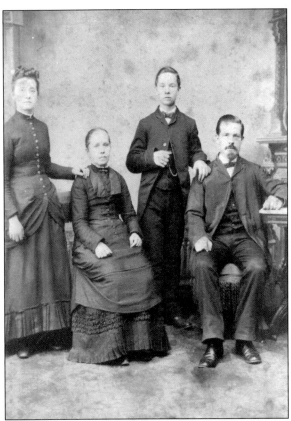

The Kunzmanns were one of the more prominent families on Troy Hill during the last part of the 19th century. The parents, Nicholas and Elizabeth, are seated, while their children Anna and John Peter are standing beside them. Nicholas actually helped build the foundation for Most Holy Name Church. (Selma Uhlig.)

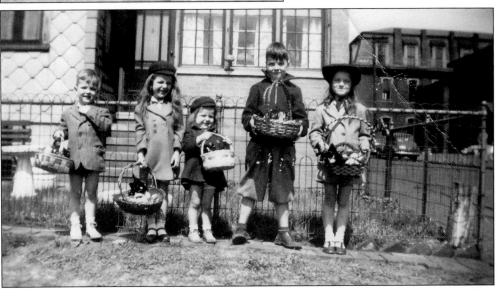

The Uhlig kids pose on Easter Morning, 1946. Pictured from left to right are Dennis, Selma, Claire, Jacques, and Marcella. Most Holy Name School is in the upper right-hand corner of the photograph. When this photograph was taken, the street was known as Harpster Street. On earlier maps it was known as Hazel Street, as well as Chestnut Street. Currently, it is again known as Harpster Street. (Selma Uhlig.)

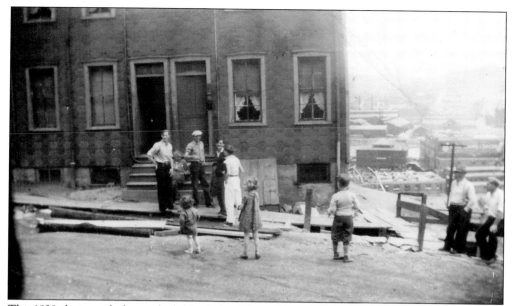

This 1938 photograph shows a little bit of what life was like on Elbow Street in Troy Hill. On the right can be seen the buildings and industry that used to be located on Herr's Island. (Selma Uhlig.)

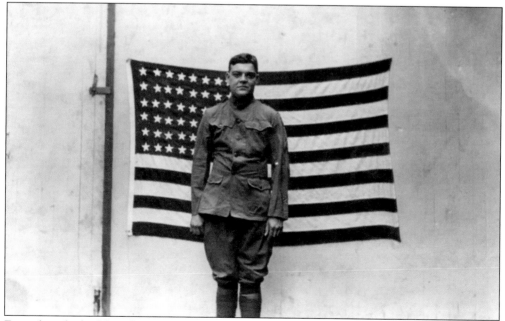

Even though the United States' involvement in World War I only lasted for a couple of years, there was a large veteran population in the city at the time. There were even special clinics set up on the North Side in the Commons to handle the veterans who may have been exposed to mustard gas. Spring Garden–native Pvt. Anton Roethlein III of the 52nd Infantry is the subject of this photograph. He was discharged in 1919. (Pat DiGiovine.)

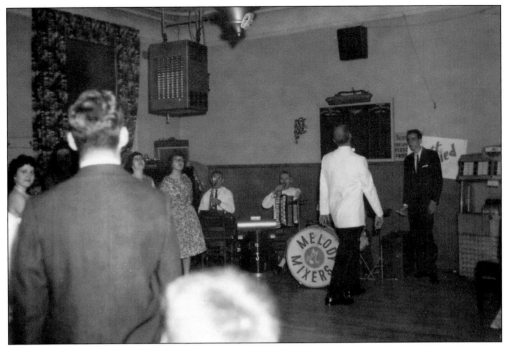

The Allegheny Social Club on Concord Street was a popular place to hold wedding receptions up through the 1960s. As the groom, Bill Leitsch, tossed the garter in the air, the single men waited to catch it. The Melody Mixers Band played on in the background. (Kate Leitsch.)

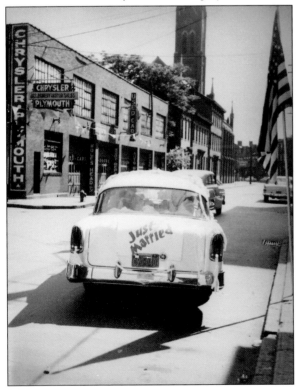

Kate and Bill Leitsch had just been married when this photograph was taken on May 30, 1961. The wedding occurred in St. Mary's Church on Lockhart Street. All of the buildings ahead of their car were demolished when Interstate 279 was constructed in the mid-1980s. On the left is the bell tower and steeple of St. John's Evangelical Lutheran Church on Madison Avenue. (Kate Leitsch.)

Pictured standing in this mid-1880s photograph is Anton Roethlein Sr. He was the owner of a wholesale liquor business on Spring Garden Avenue. Like many prosperous businessmen of the day, he was active in Allegheny City politics. He was also a strong financial supporter of St. Joseph's Orphanage on Troy Hill. The German children of the orphanage called him "*Geist Vater*," which meant "Godfather." (Pat DiGiovine.)

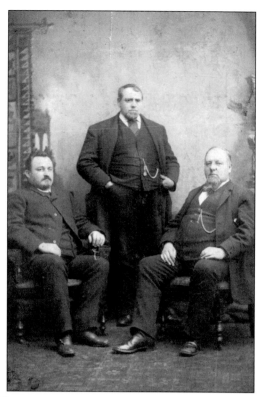

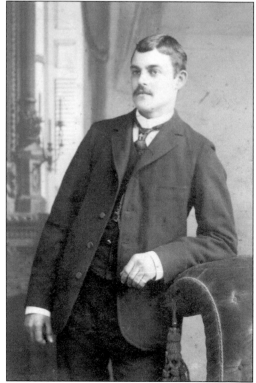

Anton Roethlein Jr. was 21 years old at the time of this portrait. He was the owner of the family wholesale liquor business until Prohibition. He and his wife, Eugenia, had 12 children. For a time, he and his family lived in the Eberhardt mansion on Troy Hill, but at the urging of his wife, the family moved back to Spring Garden. He died in 1939 at the age of 76. (Pat DiGiovine.)

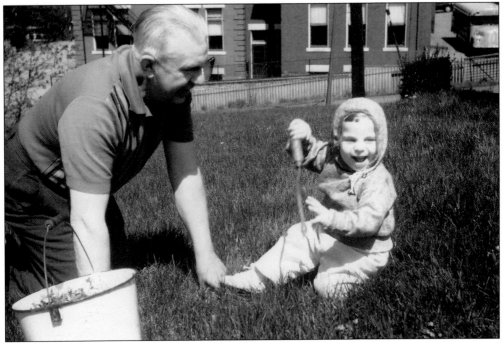

Al Skornica was a lifetime member of the Mount Troy Volunteer Fire Company. He is pictured here in the early 1960s with his grandson Ricky. The Reserve Township School at the top of Homestead Street is in the background. (Richard Luksik.)

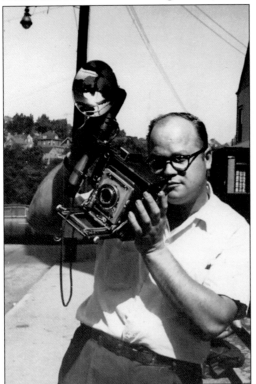

Bob Kablack was the official photographer for the Democratic Committee in Allegheny County. As such, he photographed and collected thank you notes from both John F. Kennedy and Lyndon B. Johnson during their 1960 and 1964 campaign trips. He also shot touring celebrities, including Liberace and Jackie Gleason, among others. He was Troy Hill's resident photographer from 1940 into the late 1970s and captured countless images of parades, weddings, political events, religious celebrations, and especially people just being people. (Dan Kablack.)

Charles Ruckert, of 2612 Mount Troy Road, is holding his son John on his lap in this May 10, 1911 photograph. Opposite him on the swing are his daughters Mildred and Hilda. The photograph was taken in their backyard; the house is still in use today. (Carol Musthaler.)

Karen Baer, on her three-wheeler, joins Pat Roethlein for some afternoon fun on the sidewalk, in front of 2450 Spring Garden Avenue. The bicycle was constructed from miscellaneous parts. All of the neighborhood kids loved the bike. The photograph was taken in 1947. This area was beyond where Wickline Lane came down and connected with Spring Garden Avenue. (Pat DiGiovine.)

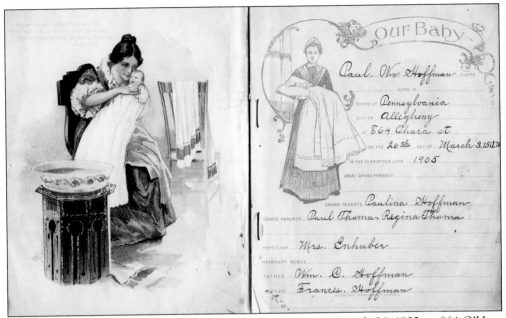

The handwritten baptism record reads:

Our Baby

Paul Wm. Hoffman — NAME
BORN IN
STATE OF *Pennsylvania*
CITY OF *Allegheny*
AT *864 Ohara st*
ON THE *26th* DAY OF *March 3.15am*
IN THE YEAR OF OUR LORD *1905*
GREAT GRAND PARENTS
GRAND PARENTS *Paulina Hoffman*
GRAND PARENTS *Paul Thoma Regina Thoma*
PHYSICIAN *Mrs. Enhuber*
MATERNITY NURSE
FATHER *Wm. C. Hoffman*
MOTHER *Frances Hoffman*

This is the baptism book for Paul Hoffman, who was born on March 26, 1905, at 864 O'Hara Street in the heart of Deutschtown. The records show that the attending physician was Mrs. Enhuber. This was a time and place when most babies were born at home with the assistance of a midwife. The parents were William and Francis Hoffman. (Marianne Yanosko.)

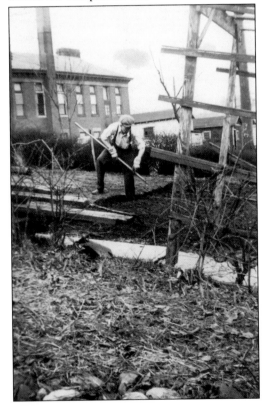

This undated photograph shows Ted Hunkele Sr. working in the garden behind his house. He was a bookkeeper for General Electric. He enjoyed his garden and spent many hours working there. He passed away in 1973 at the age of 65. Notice the Reserve Township School in the background. (Ted Hunkele Jr.)

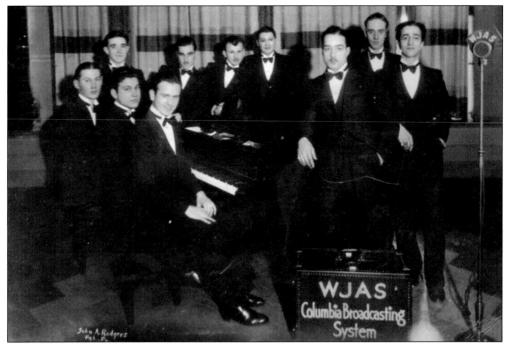

Baron Elliot, whose real name was Charles Craft, was born in Troy Hill and was raised in Reserve Township. His first radio gig was for WJAS-AM in the 1930s, which was where he and his band performed live radio shows featuring the music of the Big Band era. During World War II, as a part of the 35th Special Services Company in Europe, he produced and performed in shows for the troops. In addition, from 1940 until 1951, the Baron Elliot Orchestra also performed a live half-hour radio show on WCAE-AM, where he developed a huge following. (Lynn Mendelsohn.)

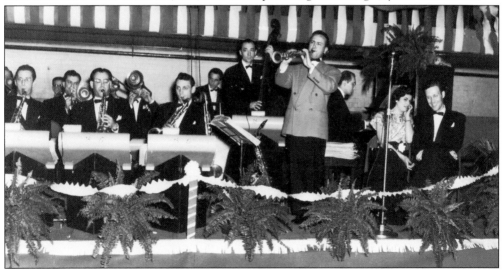

Baron Elliot, pictured in the light-colored jacket in this photograph from the 1940s, was a Pittsburgh musical legend. The Baron Elliot Orchestra performed in such local haunts as the West View Danceland, Kennywood, and the William Penn Hotel. As was typical of the day, his orchestra, as a member of a group of "territory bands," also performed at major venues in big cities like Chicago, New York, and Washington, DC. (Lynn Mendelsohn.)

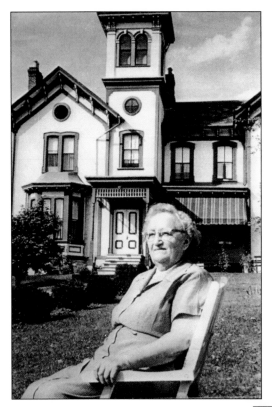

This photograph appeared in the *Roto* magazine, which was a supplement of the *Pittsburgh Press*. Agnes Wind is pictured in front of her beautiful old home in the summer of 1961. This house, when it was constructed in the 1890s, was considered to be a part of Reserve Township. The Diocese of Pittsburgh had considered moving St. Boniface Church to this location. St. Boniface remained in its present location, and the Wind house was lost forever. (Edward W. Yanosko.)

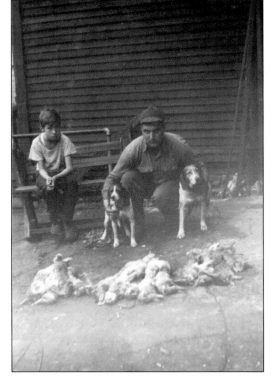

Joe Obman of 71 Luella Street in City View was an avid hunter. He is pictured here with his favorite hunting dogs and a day's worth of rabbits. In the 1940s, the northern suburbs of Pittsburgh just outside the city were prime hunting areas. Joe's mother, Margaret, who was born in Germany, would turn the rabbits into Hasenpfeffer complete with potato dumplings and cabbage. (Edward W. Yanosko.)

Ralph Haring towered over his baby sisters Helen and Caroline in this 1929 photograph. The family lived on Houston Street on what is considered one of the highest points of Reserve Township. Notice the outhouse in the background. (Sr. Margaret Haring.)

Betty Jane Cornett was born on November 24, 1932, while her family was living in Spring Hill. At the age of eight, she moved along with her family to Troy Hill. Always the athletic type, she is pictured in this photograph overlooking the Heinz plant. (Mary Lou Carr.)

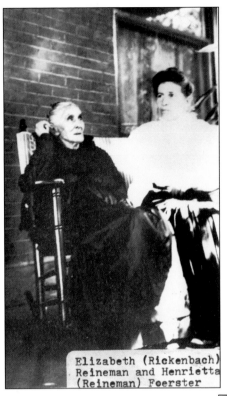

Elizabeth (Rickenbach)
Reineman and Henrietta
(Reineman) Foerster

Elizabeth Rickenbach Reineman (left) was a member of the Rickenbach-Voegtly family that settled on a tract of land that was purchased in 1823 from James O'Hara. She inherited sizeable pieces of property in Allegheny City, Spring Hill, and Troy Hill from her grandfather Henry Rickenbach Sr. and her father, Henry Rickenbach Jr. Her husband, Adam Reineman, extended these holdings into a major real estate development on Troy Hill and the adjacent communities. She is pictured here with her daughter, Henrietta Reineman Foerster. (WPHS Library.)

Emma Hartje Reineman (left) was the daughter of August and Henrietta Goehring Hartje. She grew up in the Hartje mansion on Spring Hill. After her marriage to Augustus Reineman, she lived on Troy Hill and raised her young family there. Following the death of Augustus's father Adam Reineman in 1899, she along with many of the Reineman family members moved from Troy Hill. She is pictured here with one of her great-grandchildren. (WPHS Library.)

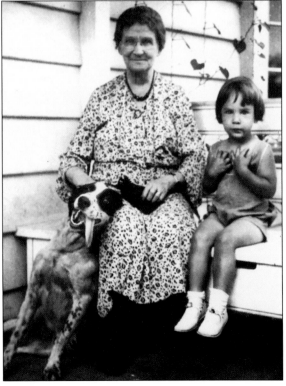

Four

EDUCATION

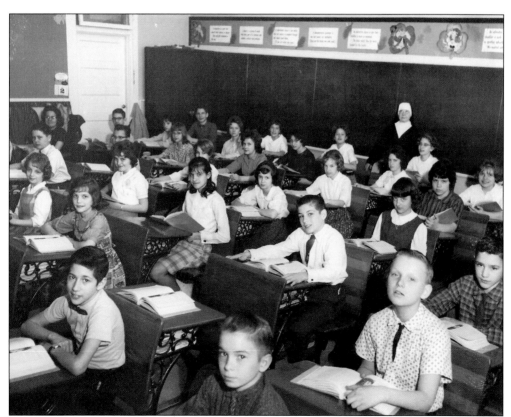

This Most Holy Name seventh-grade class is presided over by Sister Philonilla. A daily theme in the classroom was boys versus girls. This was especially the case during the recitation of paragraphs from the history book. The students in the picture are all posed nicely and perfectly for Mr. Kablack. (Dan Kablack.)

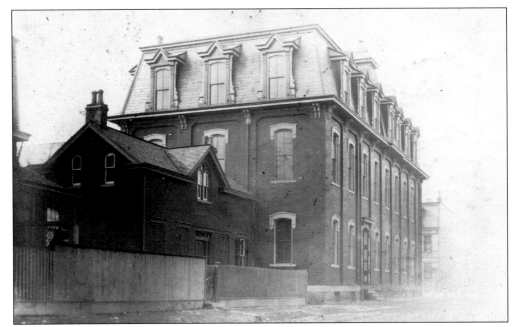

The very first children taught at Most Holy Name had their lessons in one of the rooms set aside for Father Mollinger's living quarters in the rear section of the church. In 1875, the parish constructed a school, with the female students being taught by the Sisters of Notre Dame and the boys being taught by the lay teachers. Three years later, the nuns took complete charge of all of the students. Total enrollment was 160. This photograph was taken prior to the 1907 construction of the new addition. (Most Holy Name Alumni Association.)

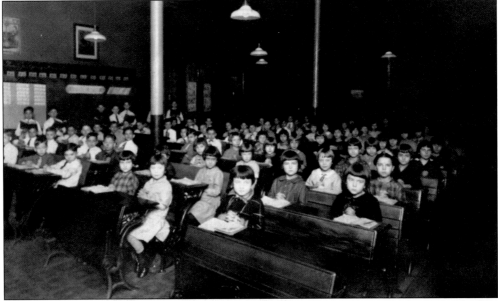

The discipline the Sisters of Notre Dame conveyed to its small students is evident in this second-grade picture from Most Holy Name School. Sitting at attention with their hands folded in front of them, the students are ready for the day's lesson. Notice all of the girls with their short haircuts. (Frank Yochum.)

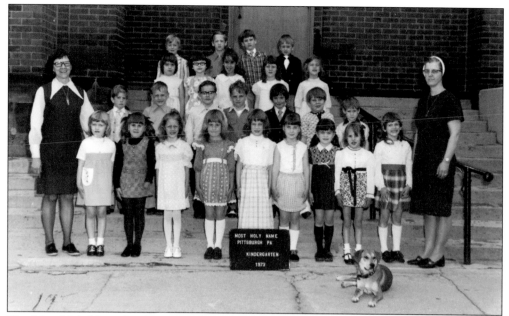

The Most Holy Name kindergarten class of 1973 is pictured here. Mary Wohleber, a noted local historian, teacher, community advocate, and lifelong resident of Troy Hill, is pictured on the left. As a fourth-generation resident, few know more about the area. The author, James Yanosko, is pictured in the last row, tilting slightly to his right for some reason. Fr. John S. Feldmeier's beloved dog Skippy is on the sidewalk in front of the group. (Most Holy Name Alumni Association.)

A young Fred Bergman took a job as custodian in 1898 at the Spring Hill School and worked there until his retirement in 1946. He was a familiar sight at the facility, and the kids and staff dearly loved him. On the occasion of his retirement, the schoolchildren put on a show in his honor. (Bee Fohl.)

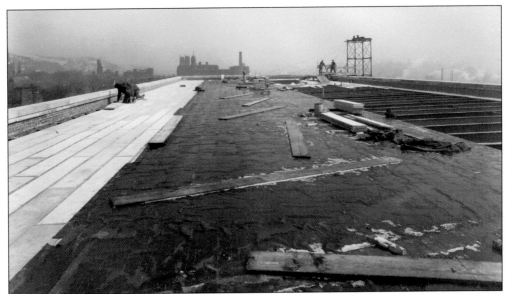

North Catholic was under construction in this October 1940 photograph. Against the cloudy sky, the steeples of the Good Shepherd, Most Holy Name, and the smokestacks of Herr's Island can be seen. On this site, 100 years prior to the construction of the high school, the parish of St. Philomena, the first German ethnic parish in the diocese, established a cemetery and small chapel. In this chapel on December 12, 1850, the first ever Catholic mass on Troy Hill was offered. (North Catholic Alumni Association.)

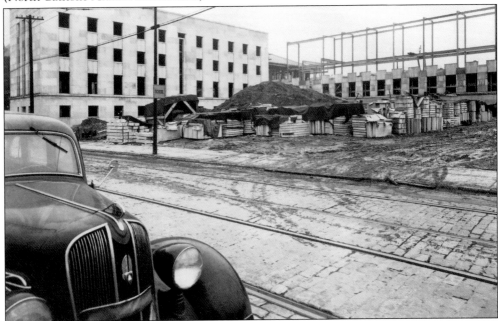

This photograph of North Catholic was taken in December 1940. The car in the foreground is a 1936 Plymouth. The annex containing the living quarters of the Marianist brothers was completed prior to the rest of the building. The St. Joseph Orphan Asylum is hidden by this annex. During this construction, the orphanage was still an integral part of student and faculty life at North Catholic. Classes were held there, and all used the chapel. (North Catholic Alumni Association.)

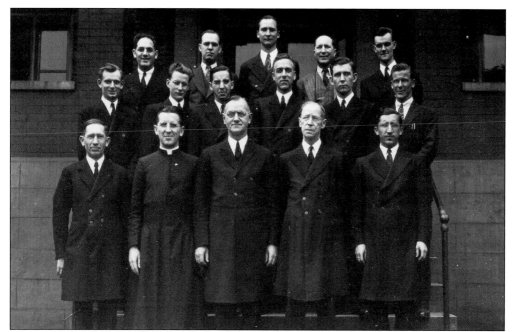

The North Side Boys Catholic School faculty for the school year of 1939–1940 is pictured here. There were 143 boys in the first graduating class in 1943. In subsequent years, the school came to be known as simply North Catholic. It was strictly a school for boys up until 1973, when it went coed. (North Catholic Alumni Association.)

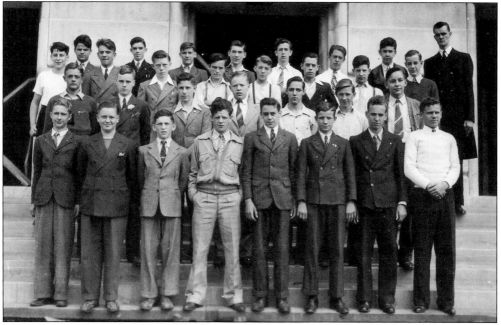

This 1939–1940 freshman class was led by Br. Richard Dineen, S.M. Many of these boys more than likely went on to fight in World War II. Nine North Catholic alums are recognized as having died for their country during the war. At the time this photograph was taken, the gymnasium they were standing in front of was still under construction. (North Catholic Alumni Association.)

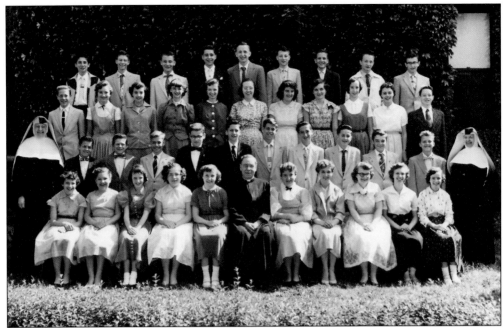

Beloved Father Feldmeier is pictured front and center in this graduation photograph of Most Holy Name class of 1955. He was appointed the sixth pastor of Most Holy Name Parish in 1952. Many of the class pictures from this era were taken in the small courtyard between the school and the convent. (Most Holy Name Alumni Association.)

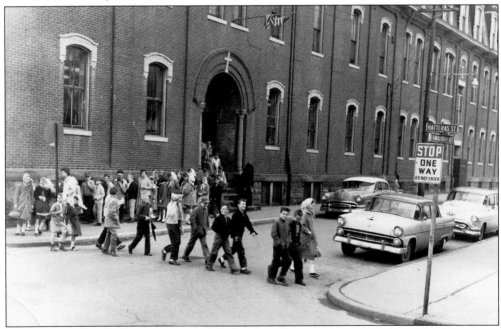

The "Big Door" is prominently featured in this 1961 photograph of the sixth-grade class exiting the building. The "Little Door" came about with the 1923 addition that connected the two buildings. It can be seen to the right of the street sign. Notice virtually all of the school girls are wearing kerchiefs or head scarves. (Dan Kablack.)

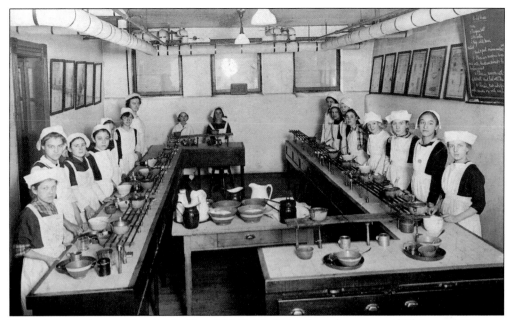

This photograph was taken in the Troy Hill Public School on the corner of Claim and Hatteras Street in 1910. The Most Holy Name students would attend vocational classes at the neighborhood public school. The back of the photograph reads, "Cooking Class, Troy Hill Public School, seventh grade once a week, Emma Brosi, Lillian Karthauser, boys learned manual training—David made a small step stool (red)." (Most Holy Name Alumni Association.)

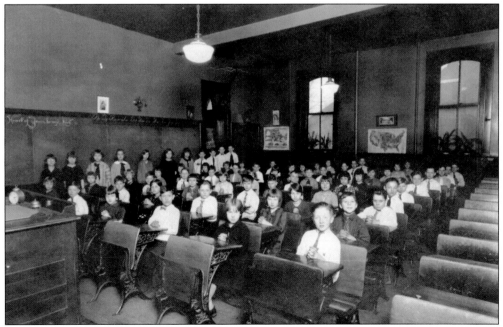

This 1924 photograph shows the fifth-grade class of Most Holy Name School. The major improvements to the school, which included connecting both structures and the installation of lavatories, were completed in 1924 for a total cost of $27,000. This particular classroom was located on the second floor of the building. (Most Holy Name Alumni Association.)

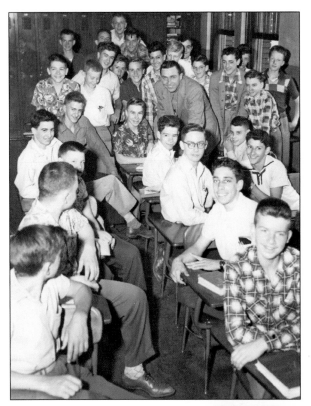

Gil Hodges of the Brooklyn Dodgers is surrounded by North Catholic High School students in this undated picture. Hodges was a friend of Br. Joe Choquette, S.M., who was a member of the staff. Baseball was the most popular sport in America at the time, and the kids in this photograph were obviously thrilled to be visited by such a big baseball star. (North Catholic Alumni Association.)

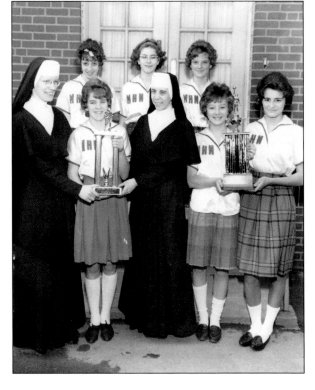

The Most Holy Name girls CYO basketball squad is pictured in this photograph from the early 1960s. From left to right are (first row) Sister Jude, Mary Beth End, Sister Corda, Mimi Lyons, and Mary Jo Stern; (second row) Sue "Leo" Leonelli, Sharon "Moz" Modzelewski, and Kathy Lunz. (Most Holy Name Alumni Association.)

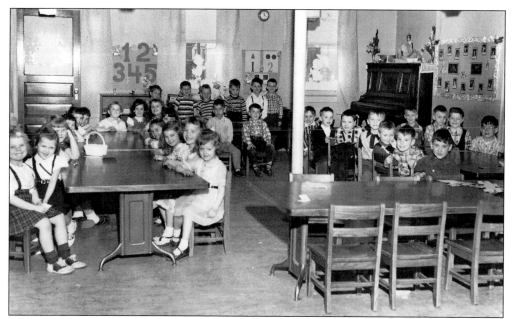

This 1956 photograph by Robert Kablack shows the second-grade class of Most Holy Name. The teacher was Mrs. Obermeier. When Hollywood visited Troy Hill in the early 1990s for the movie *Hoffa*, starring Jack Nicholson and Danny DeVito, much of the property around Most Holy Name Parish was temporarily converted back to how things may have looked during the 1930s, 1940s, and 1950s. (Dan Kablack.)

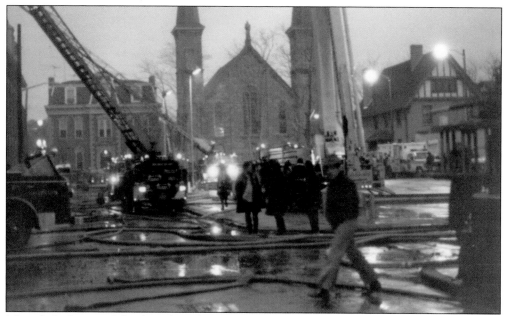

Many kids dream of the day when their school would burn to the ground, but on March 29, 1979, this nightmare became a reality for the students of Most Holy Name. The electrical fire occurred during the evening, and thankfully, no one was injured. The charred remains of the school were torn down and within two years a new, smaller building was dedicated. (Most Holy Name Alumni Association.)

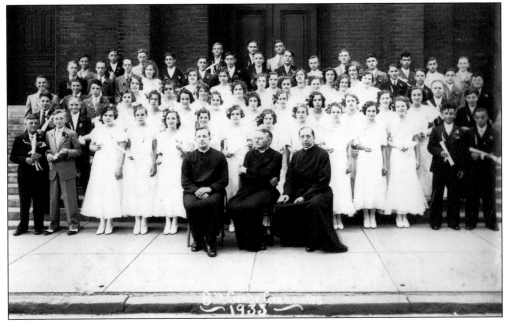

The 1933 graduating class from Most Holy Name School is pictured in this photograph. The Reverend Godfrey Pfeil is pictured front and center, looking off to his right. He was the fourth pastor to serve at Most Holy Name and was beloved by his parishioners. On his passing the following year, he lay in repose in the church. He served as pastor for just over a decade. (Most Holy Name Alumni Association.)

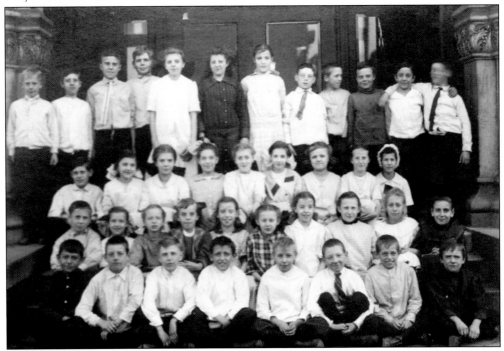

This photograph was taken on the front steps of the Spring Hill School on Damas Street in 1914. The teacher for this class was Helen M. Brown. (Carnegie Library.)

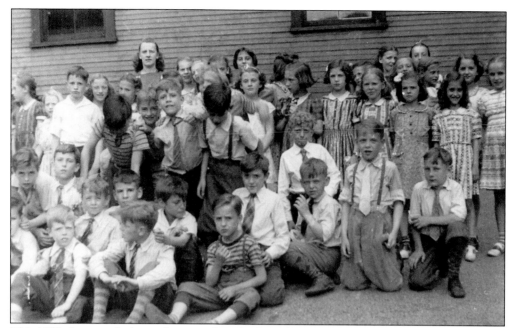

This 1938 photograph shows the second-grade class of St. Boniface. The teacher standing in the back is Miss Shea. The kids are facing the school building, and the church hall was behind them. The church hall was used for school plays and social events. Notice how the boys are grouped separately from the girls. (Edward W. Yanosko.)

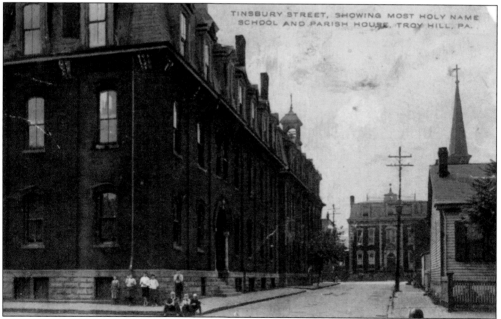

Most Holy Name School is prominently featured in this postcard. As enrollment increased, the parish continued to expand the school. In 1907, a new school was erected next to the original building. The 1923 addition connected the two buildings. Lavatories were added during this addition. This part of the building also contained access to a new and improved St. Anthony's Lyceum. (Marlene Dickson.)

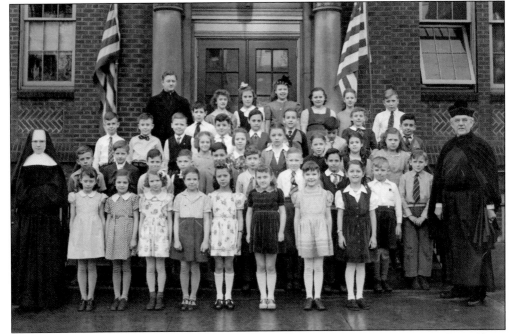

This is the St. Ambrose third- and fourth-grade class picture from 1944. The parish itself was established in 1894. A temporary church was built on donated land with donated material. Shortly afterwards, a new combination church-and-school building was completed. The school that is featured in this photograph was completed in 1928. A century after forming, due to the declining Catholic population in the area, St. Ambrose was merged with St. Boniface to form the new Holy Wisdom Parish. Sr. Mary Gemma is pictured on the far left. Father Fink is pictured standing in the back row, and Father Merz, the pastor at the time, is on the right. (Carol Musthaler.)

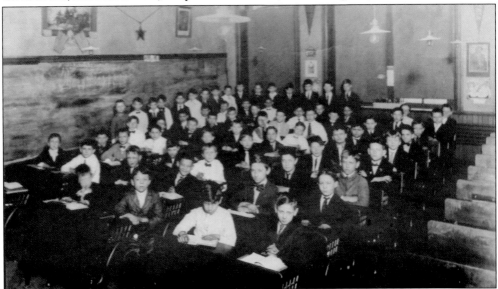

This photograph from the early 1910s shows the third grade class of St. Mary's School. Note the absence of girls. At this time, the boys were taught separately in different classrooms. This predominantly German school was located on Lockhart Street. (Marianne Yanosko.)

Five

FAITH

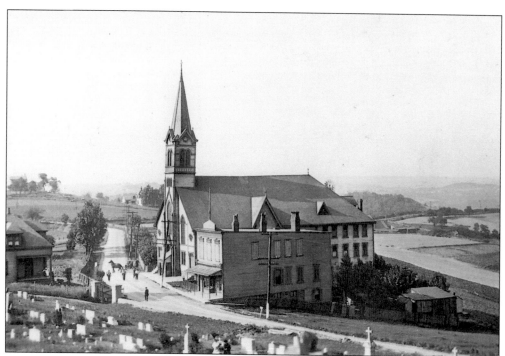

This 1915 photograph of St. Aloysius Church was taken from Most Holy Name Cemetery. The area around the church was still largely just rolling farmland. At this time, the church was still in its original form. The cornerstone was laid on July 10, 1892, with the first mass celebrated on January 8, 1893. The land where the church was built was donated by Aloise Niederst and Michael Schmitt. In addition to receiving gifts from parishioners, fundraisers were common occurrences for the church, as with all religious organizations. One 50¢ raffle in particular from July 1909 offered a horse, harness, and buggy, in good condition, to the winner. (Frank Yochum.)

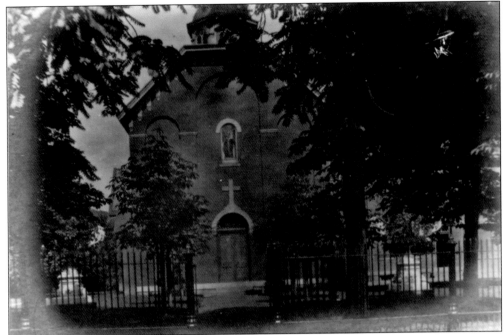

This early photograph of St. Anthony's Chapel was taken before the construction of the addition. This original structure was built in the 1880s and encompassed what is presently the sanctuary and front part of the nave. Fr. Suitbert G. Mollinger of Most Holy Name Parish built the chapel to house his ever-expanding collection of religious relics. (Chapel Museum.)

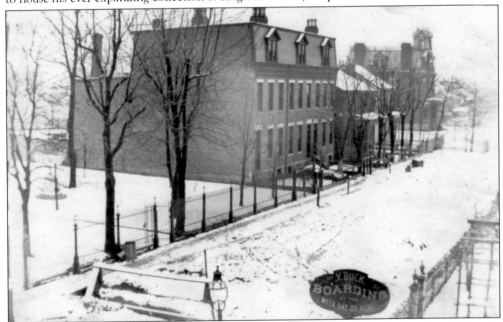

This photograph was taken prior to the construction of the addition of St. Anthony's Chapel. In the upper right is the Eberhardt property, which was known at the time as Washington Park. This property is still standing but has been converted to a multiunit dwelling. In the lower right is a sign for V. Buck Boarding, offering services "by the week, day, or meal." (Chapel Museum.)

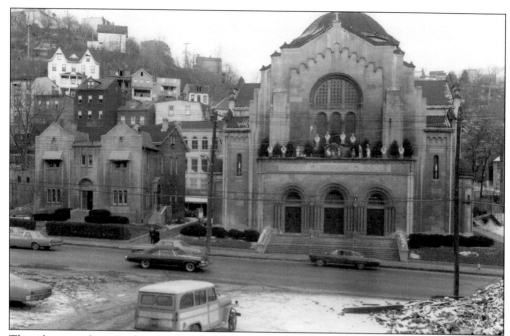

This photograph was taken at the height of the controversy as to whether or not St. Boniface should be torn down to make way for the Interstate 279 expressway. It was taken by Dean Salisbury and appeared in the *North Hills News Record* on January 9, 1974. The hillside to the left of the church is City View; to the right is Spring Hill. (James Eberz.)

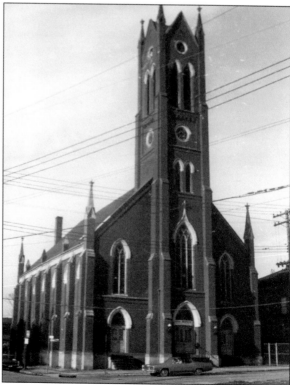

The first St. John's Evangelical Lutheran Church is featured in this 1972 photograph. The building was torn down in the mid-1980s to make way for Interstate 279. For generations, it stood on Madison Avenue. The demolition of this church was one of many reasons that many residents of the area opposed the construction of the new highway. The congregation also founded St. John's Hospital in Brighton Heights, St. John's Orphanage, and St. John's Home for the Aged. The church's cemetery in Spring Hill offers some amazing views of the city. (Carnegie Library.)

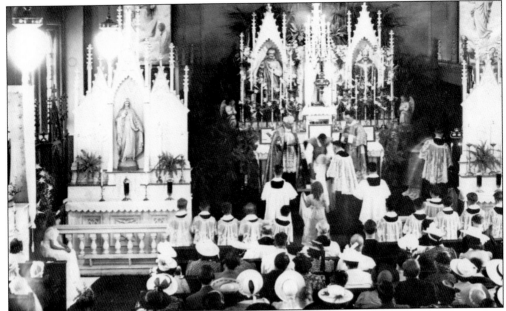

Fr. DeSales H. Zang, O.S.B., is pictured in this 1941 photograph taken at St. Ambrose church in Spring Hill. The celebration that is shown taking place was Father Zang's first mass at his home parish with his family and friends. In the photograph, his niece Lois Schweiger is presenting him with the symbolic wreath. He was ordained on June 15, 1941, at St. Vincent's Seminary in Latrobe. (Lois Schlieper.)

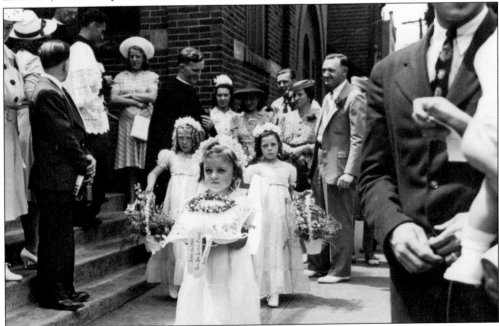

The little girls lead the procession out of St. Ambrose Church after Fr. DeSales H. Zang, O.S.B., said his first mass. The ceremony of the flower girls and the wreath bearer was a European tradition that came to this country and continued through the 1960s. Lois Schweiger, niece of Father DeSales, is pictured carrying the wreath. (Lois Schlieper.)

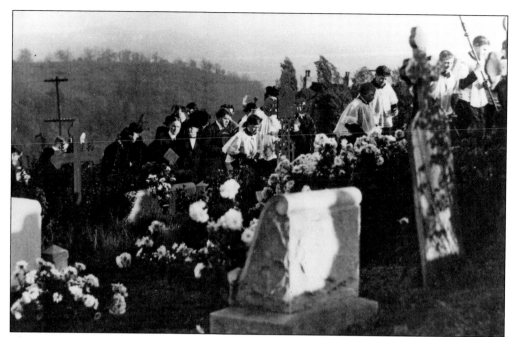

This 1914 photograph shows a procession on the occasion of the Feast of All Souls Day, celebrated on November 2. The procession began at Most Holy Name Church on Troy Hill and ended in the Most Holy Name Cemetery on Mount Troy Road, over two miles away. The parishioners would recite the Rosary as they walked. (Most Holy Name Alumni Association.)

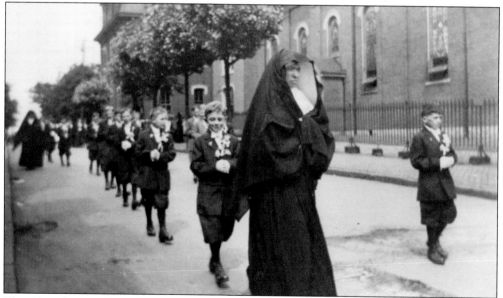

This 1914 photograph shows the Most Holy Name First Holy Communion class marching down Harpster Street. The Reverend Michael Mueller was the pastor at the time. He oversaw many of the structural improvements that occurred at Most Holy Name Parish, including the excavation beneath the school and the church. Any parishioner who has ever attended a church function in the basements, like the Harvest Festival or bingo, should think of the vision Reverend Mueller had for the parish. (Most Holy Name Alumni Association.)

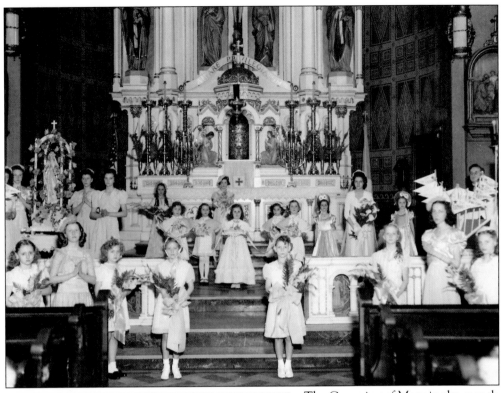

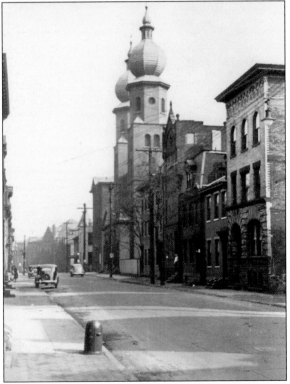

The Crowning of Mary in the month of May has long been a cherished tradition among Catholics. During World War II, these celebrations took on a patriotic theme. Letters to servicemen serving abroad adorned the sanctuary of St. Mary's Church on Lockhart Street. Many of the girls in this picture, taken in the mid-1940s, had fathers, brothers, and uncles in the armed services. (Kate Leitsch.)

This picture was taken on Lockhart Street in the 1930s. St. Mary's Church has undergone several transformations and renovations over the years. For example, Byzantine-style domes originally rested on each steeple. The ones pictured here are a more conventional onion style. St. Mary's School is also visible in the photograph. (Carnegie Library.)

This 1880 photograph is one of the earlier shots of Most Holy Name Church. Notice how different the entrance doors and the church as a whole look from today. When this photograph was taken, the church was roughly 100 feet in length with only half of that being used for church services. The extension of the church at the front end and the erection of the belfry were completed in 1898 by Father Duffner. (Most Holy Name Alumni Association.)

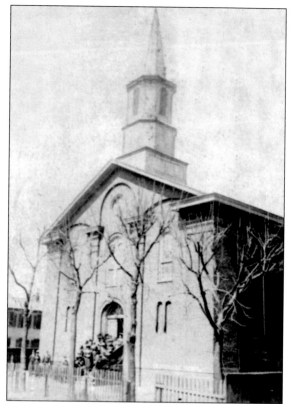

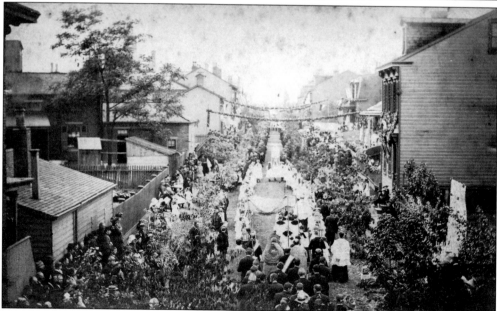

This 1890 photograph shows the Corpus Christi procession. This was an important year for Father Mollinger, who most certainly took part in this celebration. In addition to his normal duties as pastor of an expanding congregation, he began construction on the addition of St. Anthony's Chapel. (Most Holy Name Alumni Association.)

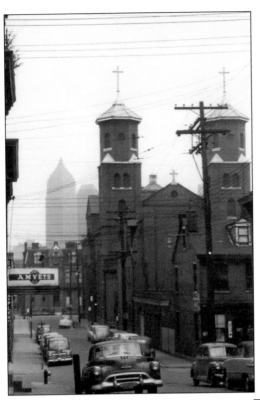

The Gulf Building in downtown Pittsburgh looms in the background behind St. Mary's Church. This picture was taken from East Ohio Street, looking down Nash Street. The final mass was on September 28, 1981, and the new Our Lady Queen of Peace Parish was created. The steeples had been changed several times during the life of the parish. (Carnegie Library.)

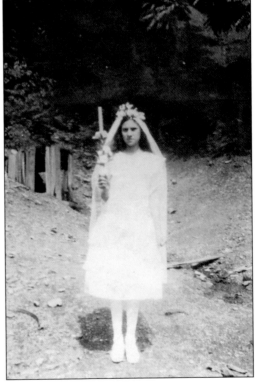

Ruth Obman, of 1924 East Street, is pictured in this First Holy Communion picture from the late 1910s. Her family belonged to St. Boniface Parish. In 1910, Pope Pius X (now Saint Pius X) lowered the age for First Holy Communion to the age of reason, which is considered to be about seven. It took several years for the old traditions to be changed, and this is why many people from that period made their First Holy Communion as teenagers. (Edward W. Yanosko.)

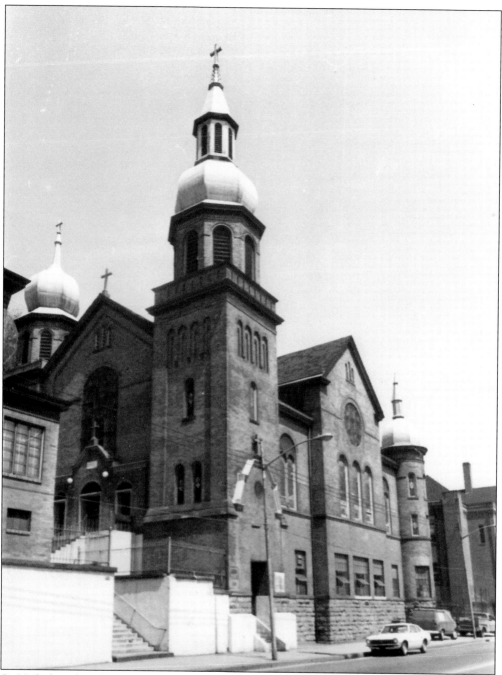

St. Nicholas Church on East Ohio Street was dedicated on January 27, 1895. It is located in what was Allegheny's 8th Ward and was situated in the heart of the Croatian community, which was also known as Mala Jaska. The immigrants from southern and eastern Europe congregated in this bustling area on the shores of the Allegheny River and in the valley below Troy Hill. Shortly after Fr. Dobroslav Josip Bozic arrived in the summer of 1894 to service this growing community, he met with Bishop Richard Phelan, of the Diocese of Pittsburgh, as well as local leaders, and plans were prepared for the establishment of the first Croatian church in America. (Carnegie Library.)

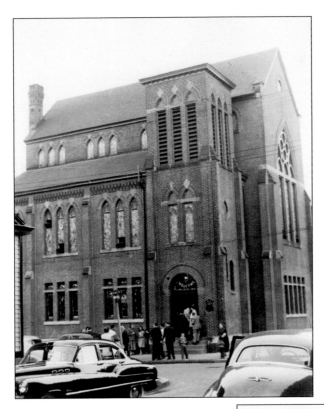

The Grace Lutheran Church, located at Tinsbury and Hatteras Streets, was dedicated in February 1899. Many of the original parishioners were the families of railroad men who worked down over the hill. Andrew Carnegie committed to half of the cost of the new organ when it was installed in 1906. This photograph was taken on September 15, 1951, on the occasion of the marriage of Shirley Kohler and Paul Cummings. (Shirley Cummings.)

This line drawing appeared in the membership booklet commemorating the 90th anniversary of the founding of St. Paul's Church on East and Foreland Streets. The artist was Elmer Zech, a member of the church. Notice the inscription on the right from the pastor, Oscar D. Hempelman, expressing his thanks for the artwork. (David Zech.)

There are four Milligan children pictured here in front of the St. Joseph's Orphanage. From left to right are (first row) Anna and Louis; (second row) Leona and Mary. This photograph was taken on March 6, 1919. Their mother, Anna M. Lankes, died on December 12, 1917, at the young age of 29. Their father, Louis J. Milligan, was unable to care for his four children and had no choice but to have the kids cared for in the orphanage. (Mary Ann Tomasic.)

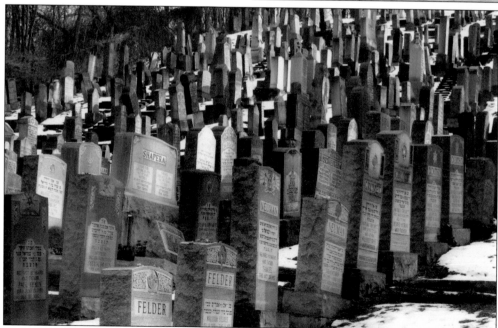

The Machsikei Hadas Cemetery, located off Geyer Road in Reserve Township, is one of seven Jewish cemeteries in the township. The founders of this congregation, located on Wylie Avenue in the Hill District, were Sephardic Jews who had fled from persecution in what is now Poland. *Machsikei Hadas* means "Defenders of the Faith." (James W. Yanosko.)

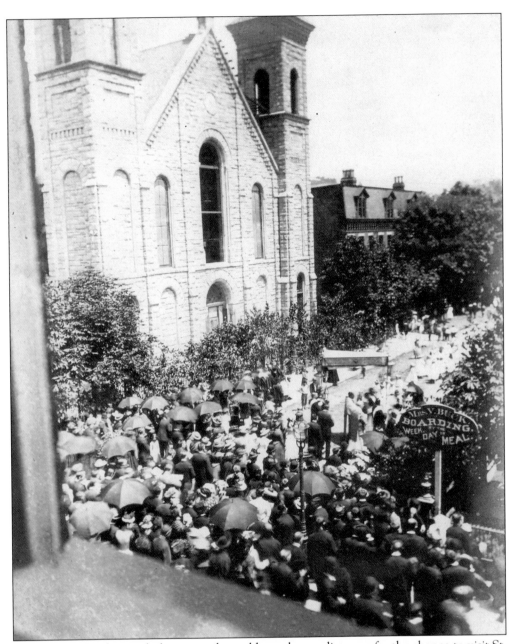

Estimated in the thousands, large crowds would travel great distances for the chance to visit St. Anthony's Chapel and to receive medical attention from Father Mollinger. He never charged for his medical ministrations; however, many of those whom he helped were very generous in their donations. Days of particular interest were the feast of St. Anthony and the Corpus Christi processions. In later years, the chapel fell into disrepair. In the early 1970s, Mary Wohleber and a group of parishioners, including Thomas Koch, Pauline Stauber, William Fichter, Cecilia Guehl, Arthur Roos, and James Spagnolo, formed a chapel restoration committee. The completely restored chapel was reopened on Sunday, November 27, 1977, after $250,000 of interior and exterior renovations had been completed. This large crowd was assembled for the dedication of the chapel addition on June 13, 1892. (Chapel Museum.)

Six

SPORTS AND LEISURE

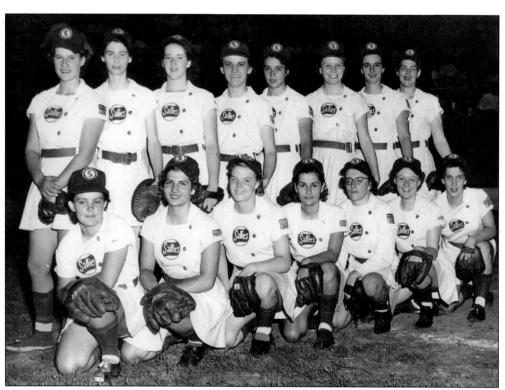

In this 1950 photograph, Betty Jane "Curly" Cornett, standing on the far left, is pictured as a member of the Springfield (Indiana) Sallies. This team was a member of the All American Girls Professional Baseball League, which was featured in the 1992 movie *A League of Their Own*. Betty Jane retired from professional baseball after the 1951 season and began a 24-year career with H.J. Heinz Company. She resided in Reserve Township until her passing in 2006. Some of her memorabilia is on display at the Senator John Heinz Sports Museum, and she is also enshrined in the Baseball Hall of Fame in Cooperstown along with the other members of the AAGPBL. (Mary Lou Carr.)

The City View Field was a popular gathering place for several generations of kids. The old property was just a clearing where neighborhood kids could play pickup games of baseball and football with whatever mismatched equipment they could find. Considering these were the days prior to any organized leagues, the larger, older kids would often play with the smaller, younger kids. The old field has been out of use for years and to this day remains a vacant piece of property, although it is now covered with trees and brush. (Edward W. Yanosko.)

Notice the old dining room table that was recycled for use as a basketball backboard in this late-1940s City View photograph. The table was donated by the Kress family from Gershon Street. The old Wind house is in the background. (Edward W. Yanosko.)

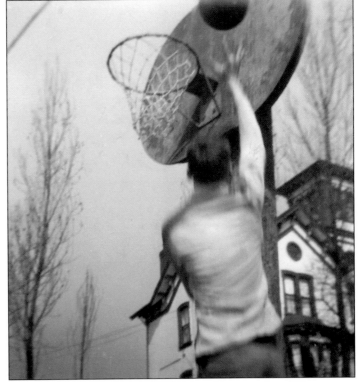

This 1940s photograph shows kids playing hockey on South Side Avenue. There were much fewer cars and trucks on the road back then, and the streets were often used for various sporting activities. These were the days before organized leagues and before kids had access to proper equipment. Hockey sticks were often made from tree branches, and the puck was a crushed tin can. (Edward W. Yanosko.)

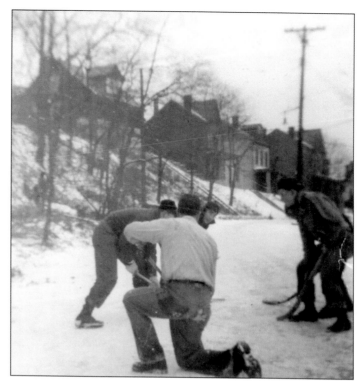

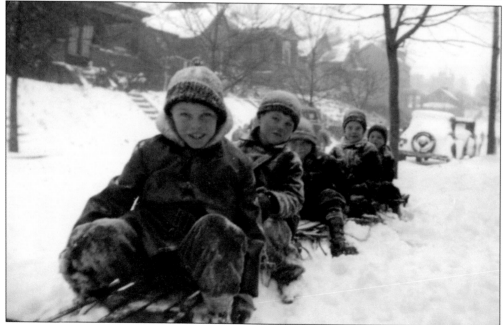

Kids take a break from a busy day of riding sleds on Harbor Street, in Spring Hill, in this late-1930s photograph. Pictured from left to right are Joe Heyl, Chuck Miller, Charles Dorsch, Mary Heyl, and Harry Heyl. In later years, these kids would venture off and take their sleds down Rockledge and Homer Streets. The streets were not plowed, and there were very few cars. Kids also rode their sleds down the Hespenhide property, which was known as the "Mountain." (Mary Hart.)

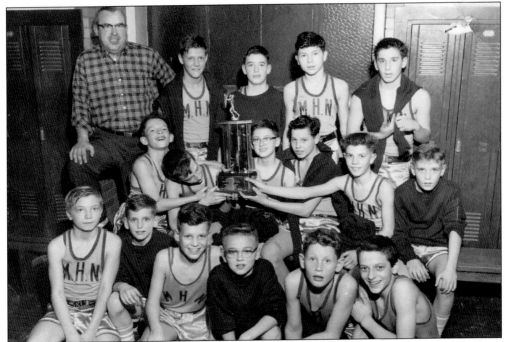

This photograph of the 1960–1961 Most Holy Name boys' basketball team was taken after they won a tournament at North Catholic High School. Coach Wallace is standing on the left. Team members include, from left to right, (first row) Jack Urbanec, Paul Lyons, Bill Florijan, Mike Billingsley, Gary Klingman, and unidentified; (second row) Bob Zoelle, Matt Weidner, Ken Billingsly, Bob Divosevic, Jerry Smith, and Mike Helwich; (third row) Dave Chambers, Leo Henderson, Charlie Sperando, and Larry Pusateri. (Dan Kablack.)

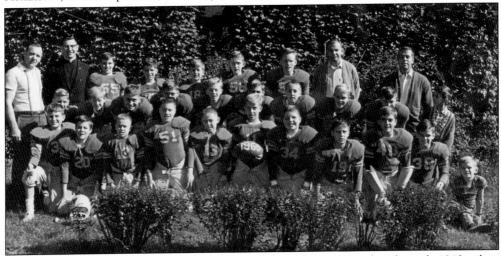

The Parish Athletic Association of Most Holy Name was first organized in the early 1940s when a boys' basketball team was founded. To meet the high cost of athletics, Father Feldmeier allowed the association to have a "Buffalo," or loose change collection, at the doors of the church on the second Sunday of each month in addition to other fundraisers. This 1965 football squad was coached by Winks Gramc (standing far left), Fred Weis (standing second from right), and Moose Huber (standing far right). Fr. Andrew Tibus is also pictured. (Most Holy Name Alumni Association.)

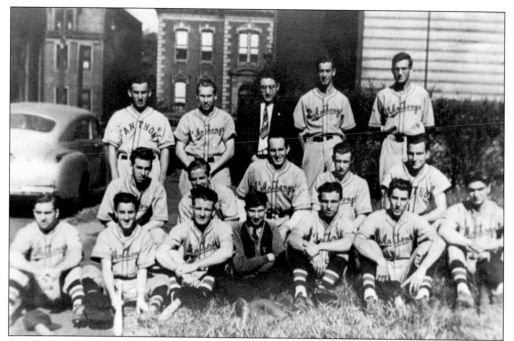

Sandlot baseball teams were prevalent throughout most of the city back in the 1940s and 1950s. This St. Anthony's squad features, from left to right, (first row) Ed Lyons, Don Roos, Ralph Miller, Bogie (the parish janitor), Joe Best, Ray Horn, and unidentified; (second row) Larry Enz, Heado Renner, Leo Lacher, Lee Henderson, and Ray Weidner; (third row) unidentified, John Enz, Alex Braun, and two unidentified. (Most Holy Name Alumni Association.)

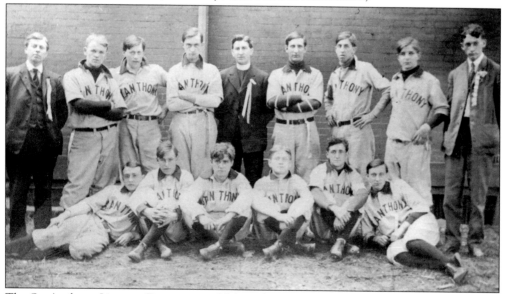

The St. Anthony Literary, Dramatic, and Musical Society was founded by Father Mollinger. It was designed as a place of recreation where men could strengthen their bodies as well as their minds amid wholesome surroundings. It was not until 1923, however, that the present St. Anthony Lyceum came into existence. The organization has sponsored countless teams over the years, but the one pictured here was the first. (Most Holy Name Alumni Association.)

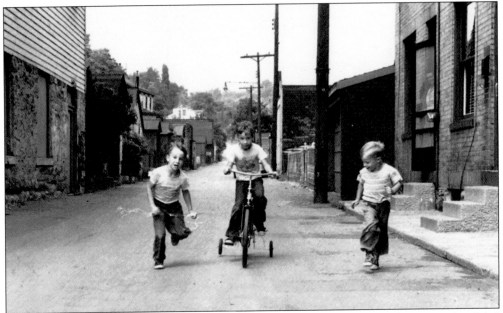

Pictured from left to right are Danny, Davey "Doc," and Wayne Kablack as they ran and pedaled toward their father, Bob Kablack. Three times a year, Memorial Day, Flag Day, and the Fourth of July, kids would tie balloons and streamers to their bikes. The neighborhood kids knew the steps on the right as "the Pot" when they played their games of "Release." The VFW Post 7090 is on the left. (Dan Kablack.)

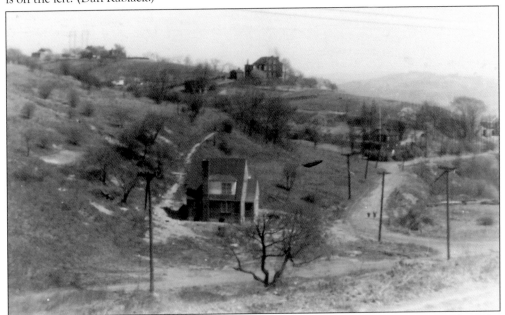

It is no wonder that Pittview Avenue was named what it was. The lack of large trees along the country road most certainly afforded residents and pedestrians a good view of the city below. Notice the small lot on the right side of the picture. A mushball league played games here. Mushball is sort of like softball, but the balls are larger, softer, and do not fly anywhere near as far when hit. (Ted Hunkele Jr.)

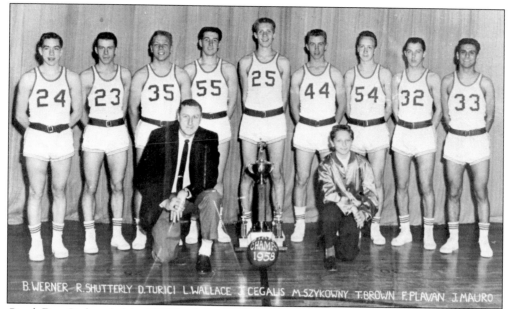

B.WERNER R.SHUTTERLY D.TURICI L.WALLACE J.CEGALIS M.SZYKOWNY T.BROWN F.PLAVAN J.MAURO

Coach Don Graham led the 1958 North Catholic Trojans to the State Catholic League Championship. His overall record of 801-436 makes him the winningest coach in Pennsylvania history. He won three State Catholic League titles (1958, 1959, and 1962) and was the runner-up two times (1955 and 1973). His teams captured 11 Class A Catholic League titles and 10 Western Pennsylvania Interscholastic Athletic League (WPIAL) Section titles. In addition to his coaching duties, he also held several teaching positions and was a guidance counselor. (North Catholic Alumni Association.)

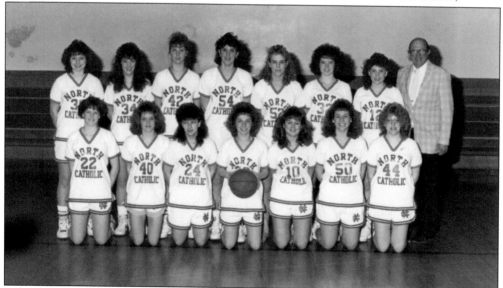

The North Catholic Trojanette basketball squads of the 1980s and 1990s achieved some truly spectacular results on the hardwood. Coach Don Barth (not pictured) guided his girls to 16 WPIAL titles and 7 Pennsylvania Interscholastic Athletic Association (PIAA) state titles (1980, 1983, 1984, 1988, 1993, 1994, and 1995). The 1987–1988 team, pictured here, amassed a 23-1 regular season record, as well as the state championship. Long time assistant coach Frank Windisch is on the far right. (North Catholic Alumni Association.)

This picture from the 1970s was taken in the backyard of Greb's Bakery, which was located at 1703 Lowrie Street. Herr's Island is pictured in the background. By the time this photograph was taken, the stockyards and industry of the island had been long gone. Sledding down hills in this area required the utmost attention from the rider. (Mike Greb.)

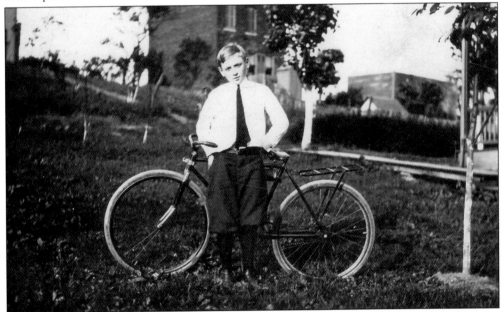

Bicycles were easily the most efficient way of getting around Mount Troy back in 1912 when this picture was taken. The rolling country roads were relatively car free and were used mainly by fellow bicyclists, pedestrians, and horse-drawn wagons. More often than not, the wagons were filled with locally grown produce on the way to the market in Pittsburgh. Anthony Offerman is the young cyclist featured in this photograph. His family lived on Thorn Drive. (Frank Yochum.)

Seven

CLUBS AND ORGANIZATIONS

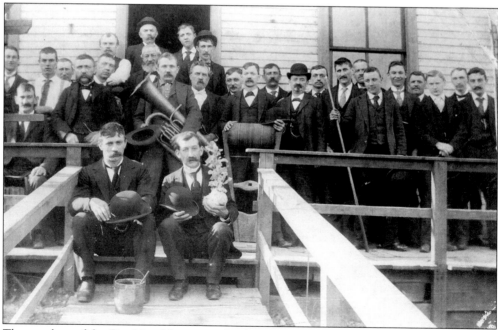

The members of the City View Hunting and Fishing Club pose for a photograph taken at the rear of the building. The men in this photograph were raised during an era when only the very affluent could spend their time at leisure activities, but as the area prospered, many of the residents began to organize social clubs focused on these outdoor pursuits. According to the *Allegheny County, Pennsylvania, Illustrated* 1896 edition, the man who did not belong to at least one was an exception, while the majority held membership in several. (Edward W. Yanosko.)

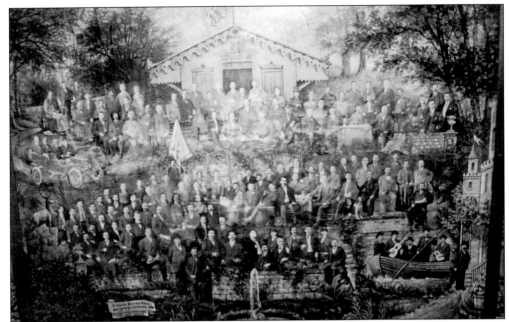

Immigrants of German descent have been settling in the Deutschtown area since the 1700s. Many of their traditions and skills came with them from the old country. The Turn Vereins were clubs designed to build strong bodies through exercise, and the Singing Societies existed for the cultivation of the voice. The Teutonia Mannerchor persisted through the war years when public sentiment was very much against its organization. The above 1904 picture is displayed in their entrance hall. (Teutonia Mannerchor.)

The Teutonia Mannerchor was founded in 1854 by a group of German men who joined together to sing the songs of the "Heimat." They have gathered in their present hall, pictured here, since 1888. The 10 men who were honored as the first members were Christ Weier, John Heckel, Peter Herdt, Joseph Lantner, J.C. Lappe, John G. Walter, Henry Gerwig, Theo Straub, Joseph Bruening, and John Luckhaupt. (Teutonia Mannerchor.)

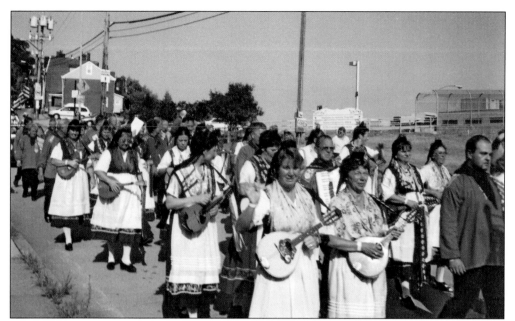

This August 2004 photograph was taken at the bottom of Troy Hill Road and Phineas Street. The group was from Germany and was here to help celebrate the 150th anniversary of the Teutonia Mannerchor. (Teutonia Mannerchor.)

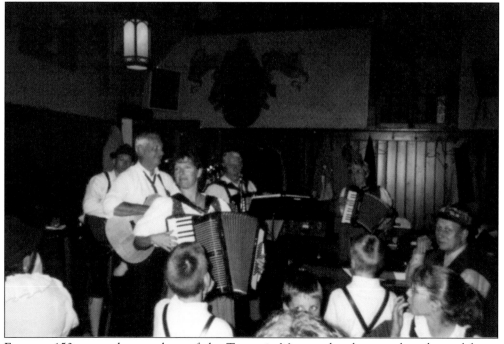

For over 150 years, the members of the Teutonia Mannerchor have gathered to celebrate the singing and dancing traditions of the homeland. They perform at the club, as well as at Sangerfests throughout the United States. They have even traveled to Germany to perform. No description of the club would be complete without mentioning the traditional German food and beer. (Teutonia Mannerchor.)

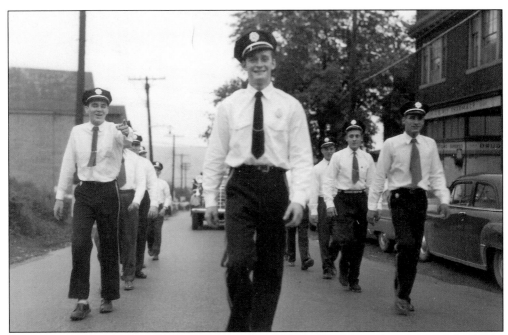

Steve Walthers led the Mount Troy Volunteer Fire Department during this parade in the 1950s. Notice Huys drugstore on the right. Many parades began at the intersection of Mount Troy Road and Pittview Avenue at the William R. Prom Memorial located just a few steps from where this photograph was taken. (Marlene Dickson.)

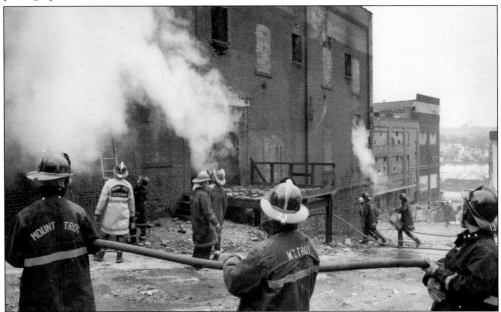

The Mount Troy Volunteer Fire Department predominantly stays in the Reserve Township area but will, if needed, venture out to some of the outlying communities. This 1973 photograph shows the firemen responding to an alarm at the Millvale Industrial Park along Route 28. In the spring of 2011, the Millvale Industrial Park, the former home of the Fried and Reineman Packing Company, was demolished. (Marlene Dickson.)

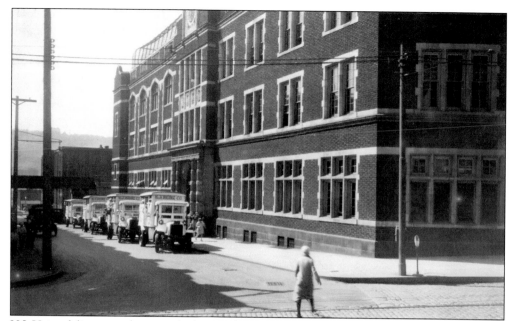

H.J. Heinz delivery trucks are parked out in front of Sarah Heinz House in this 1930s photograph. Notice the fenced in area at the top of the building. Kids would play volleyball and other athletic activities up on the roof when the weather permitted it. This building was constructed in 1913 after the demand for services outgrew the space at Covode House. This precursor to the Sarah Heinz House was founded in 1901 by Howard Heinz. (Sarah Heinz House.)

In the 1920s, Heinz House camp was established as a place where inner-city kids could get away to the country to experience fishing, canoeing, looking for crayfish, making campfires, sleeping in tents, and playing rousing games of capture the flag. The camp is located on the banks of the Slippery Rock Creek near McConnell's Mills. This 1962 photograph shows George Clark, the former Spring Garden School principal, joking with some of the campers. (Dan Kablack.)

Young boys and girls from all over the North Side of Pittsburgh have learned many valuable skills and life lessons at Sarah Heinz House. One week they may be building something in wood shop, and the next week they may be learning how to swim, shoot a basketball, or even how to sing a song. In addition, there were several other activities that were specifically geared toward young women, like cooking and sewing. Girls were admitted into Heinz House in 1903. (Sarah Heinz House.)

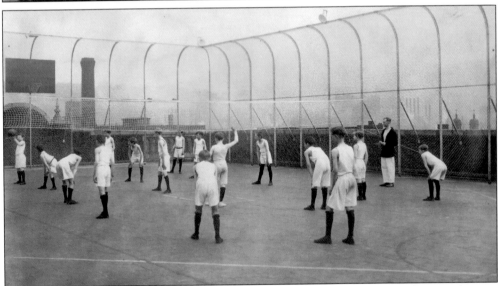

There is no doubt that the uniforms the kids are required to wear have changed quite a bit over the years. This picture was taken on the roof of Sarah Heinz House and shows a volleyball game sometime between 1911 and 1920. Notice the twin steeples of St. Wenceslaus Church on Progress Street. St. Wenceslaus was founded in 1871 for the growing Czech population in the area. In 1900, a new church building was constructed on the site and is seen here. Because of the declining population in the area, the parish was suppressed, and the final mass in St. Wenceslaus took place on October 15, 1989. (Sarah Heinz House.)

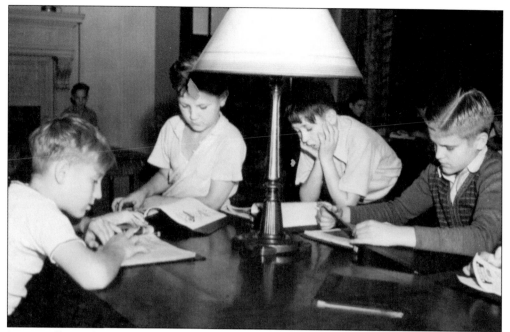

It is not all just about rigorous physical activity at Sarah Heinz House. This photograph by Luke Swank shows a group of boys reading magazines. To this day, in addition to athletic skills, the club promotes academic and leadership skills. There is still a reading room dedicated to the quiet pursuit of knowledge. (Sarah Heinz House.)

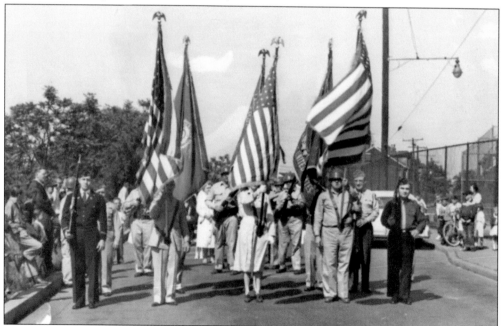

A favorite parade route on Troy Hill was from Cowley Field, where this 1959 photograph was taken. The parade would proceed down Goettman Street, past North Catholic, then Lowrie Street, and back to the Voegtly Cemetery. For hundreds of youths for several generations, this was how their little-league baseball and softball seasons began. (VFW Post 7090.)

The Mount Troy Ethnic Group, pictured here, used to meet at the Mount Troy United Church of Christ and discuss current local issues as well as former customs and traditions. This group formed in 1974. Ray Dumrauf, one of the original leaders of the group, is pictured on the right with his hands on the shoulders of his wife, Rose. (Marlene Dickson.)

This mid-1950s photograph shows the Ladies Auxiliary. This picture was taken at the intersection of Mount Troy Road and Pittview Avenue. The first official meeting of the Ladies Auxiliary was held in August 1950 with 36 women in attendance. Over the years, this organization has conducted countless fundraisers for the firemen, as well as for other causes. This organization continues to meet. One of its main fundraisers is the Good Friday fish dinner. (Marlene Dickson.)

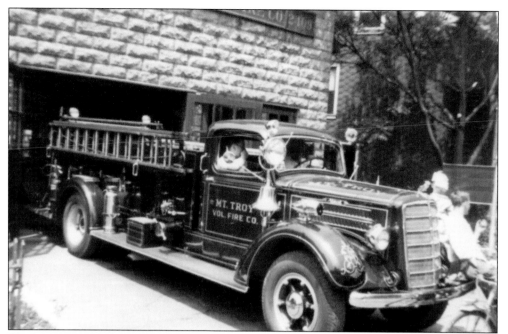

The Mount Troy Volunteer Fire Department has had three different homes since it was founded in 1915. The location in this photograph was 2407–2409 Mount Troy Road. They occupied this firehouse from 1922 to 1957, when they moved into the present firehall on Lonsdale Street. (Marlene Dickson.)

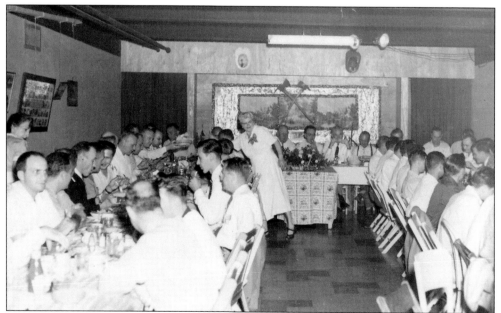

The Mount Troy Volunteer Fire Department celebrates at a banquet in this 1954 photograph. The celebration took place at Roch's Tavern on Mount Troy Road. Anita Roch, in the white dress, tends to the needs of the guests. Three years later, the fire department constructed a new engine house on Lonsdale Street. A decade after that, the ballroom addition was completed. (Marlene Dickson.)

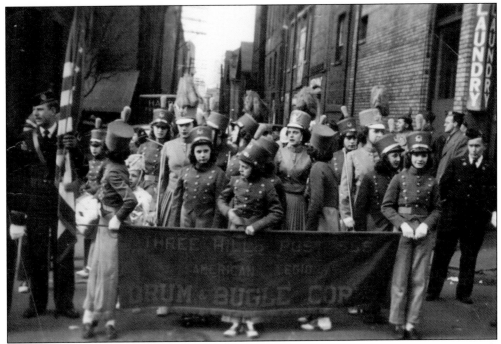

Three Hills Post 565 American Legion Drum & Bugle Corps is seen in this undated photograph taken near Madison Avenue. American Legion Post 565 is located in a building on Hatteras Street that was formerly used as a Turn Verein. (Mary Lou Carr.)

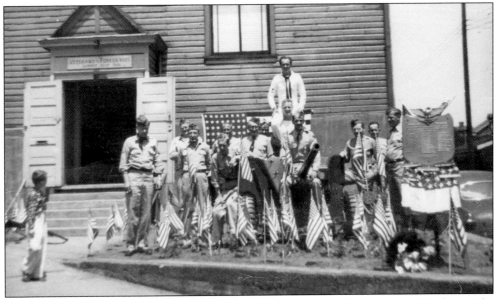

A group of veterans, including Adam Eckhardt, Pete Dauer, George Breining, Ray Weidner, Mike Sibenac, Jack Forgas, Mike Chambers, Dutch Bauerle, Andrew Sokal, Marty Vidt, and Edward Cornett, pose on the cannon outside of the VFW 7090 after the 1954 Memorial Day parade. Down the alley from this club stood the Civil Defense Building. During the frequent air-raid drills in the 1950s, a siren would sound in this building. The Liedertafel German Singing Club was located at this site prior to the VFW occupying the premises. (Mary Lou Carr.)

Eight

COMMERCE AND OCCUPATIONS

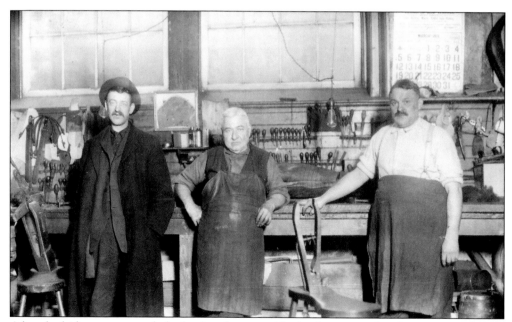

After the hides were tanned, the leather shops would take this material and turn it into durable goods. Leather from cattle hides would be turned into harnesses, shoes, and industrial belts. Sheepskins would be used for purses and travel bags. Hog skins would be used for gloves and book covers. Some of the heavier leather products appear to have been shipped to Europe while the lighter items remained in the local markets. This 1916 photograph shows a typical shop in the Deutschtown area. (Edward W. Yanosko.)

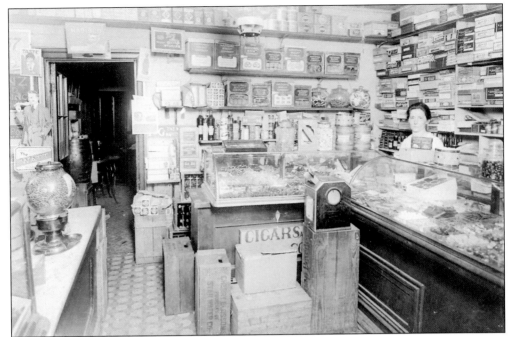

Frances Hoffman operated her general store on Madison Avenue. In addition to canned goods, candy, tobacco, and coffee, she also ran a successful numbers game out of the store. Periodically, the local police would interrupt the action, but for the most part, this type of gambling was left alone. Many boardinghouses and restaurants of the day made it a point to advertise that their establishment was free of the vice of gambling. (Edward W. Yanosko.)

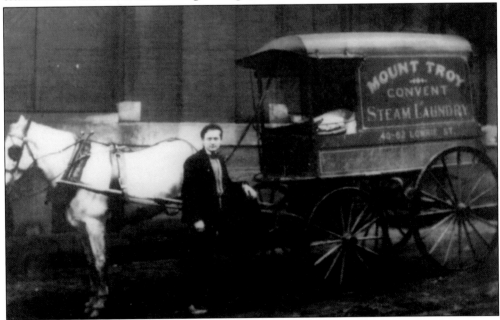

Even though this place was called the Mount Troy Convent Laundry, it was actually located in Troy Hill. It was situated in a separate facility in the back corner of the property of the Sisters of Good Shepherd Home. (Edward W. Yanosko.)

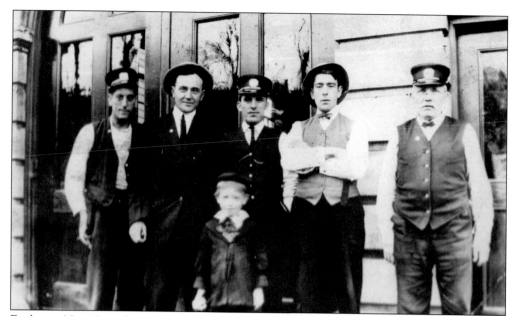

Firehouse No. 16 was located on South Side Avenue in City View. According to the 1909 City of Pittsburgh Directory, this firehouse was then identified as No. 56. This undated photograph features several of the men who worked at this fire department. (Frank Yochum.)

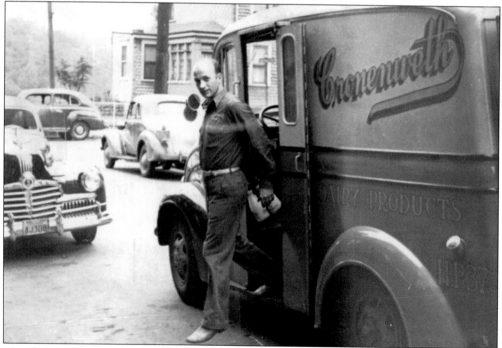

The Cronenweth Dairy was located on Herman Street back by Gardner Field. It was incorporated in 1931. The owners were Annie Cronenweth and her two sons Ray and Edward. It was taken over by Harmony Dairy in 1964. It was not long after this that the idea of having a milkman deliver the fresh product to one's house simply faded away. This photograph dates from the 1940s and shows the Cronenweth milkman making his delivery to a house on Claim Street. (Dan Kablack.)

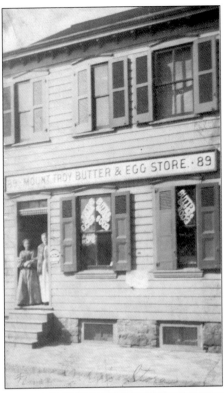

The Mount Troy Butter and Egg Store was actually located in Troy Hill on Hamilton Street. This former 13th Ward of Allegheny City had many streets that changed names after the annexation. This street became known as Hatteras Street. This building was used in later years as a pizza parlor, often catering to students from Most Holy Name. (Frank Yochum.)

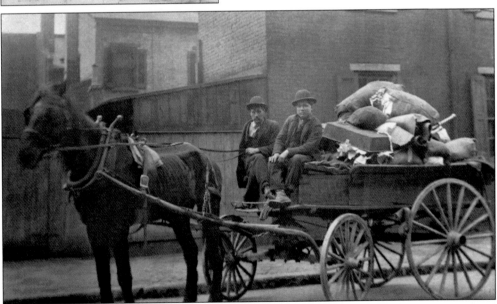

Joseph Obman, who lost his arm in a railway accident, is pictured on the left in this undated photograph. Even though he only had one arm, he still managed to get by as a scrap dealer or rag picker. Obman was born in Allegheny City in 1882 and married Margaret Dauer Reitlinger in 1905 at St. Mary's Church. They lived on East Street and then Luella Street in City View. Many old timers will remember the junk man, as he made his way through the neighborhood, call, "Rags! Old Iron!" (Edward W. Yanosko.)

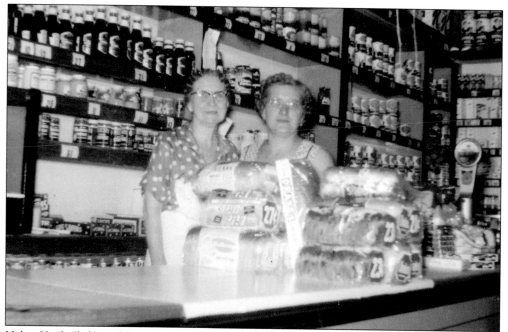

Helen Koch (left) and Rose Greb are pictured standing behind the counter in Koch's Grocery Store, which was located at 1721 Lowrie Street. Notice the many familiar brands that are still available to this day and the bread on the counter that sold for 23¢ a loaf. No market from Troy Hill would be complete without Heinz ketchup on the shelves. (Mike Greb.)

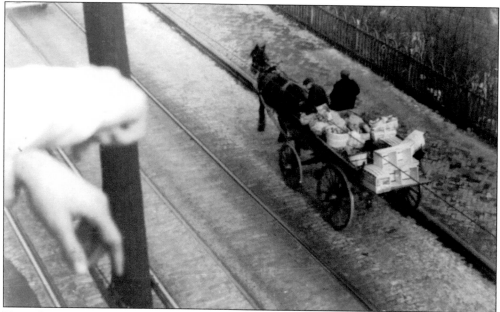

Horse-drawn wagons carrying produce to local markets were a common sight. They shared the roads with automobiles, streetcars, and delivery trucks. Keeping city streets clean has always been a major concern for city planners. One way this was accomplished was by residents coming out and scooping up any horse manure that may have been left behind. Many people had gardens, and free fertilizer was not to be wasted. (Dan Kablack.)

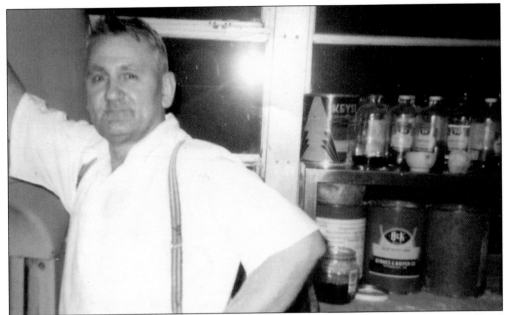

Bill Greb, the proprietor of Greb's Bakery, had baking in his blood. His grandfather owned and operated his own bakery in Germany. He immigrated to the United States in the mid-1930s at the age of 21. When he arrived here, there were four other Greb's Bakeries in other parts of the city that were owned by his brothers. His store on Lowrie Street was opened in the late 1940s but had closed down by the mid-1960s. (Mike Greb.)

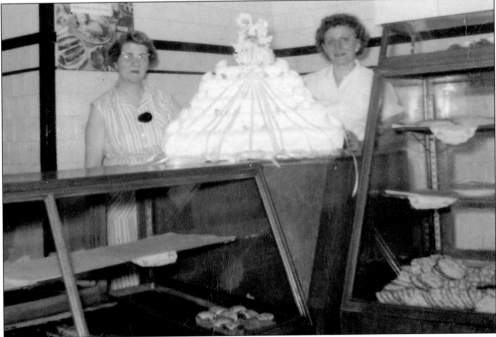

Greb's Bakery was located at 1703 Lowrie Street and, for a while, was one of three bakeries that operated on Troy Hill. Viola Mann (right) and Mary ? are pictured with a wedding cake in this photograph from the 1950s. Wedding cakes were a specialty at the Greb's Bakery. (Mike Greb.)

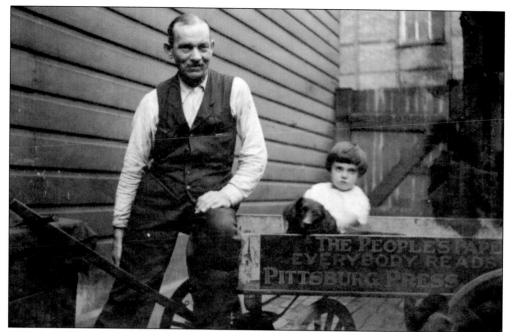

William Stalter is pictured in this undated photograph with his *Pittsburg Press* delivery wagon. The *Press*, founded in 1884, was one of several daily newspapers that published prior to the First World War. It competed with the *Pittsburgh Sun-Telegraph*, the *Pittsburgh Dispatch*, and the *Pittsburgh Post-Gazette*. The paper added the "H" to its mast in 1921. The *Press* also competed with the *Freiheits Freund*, the leading German daily paper published in western Pennsylvania. (Phyllis Greb.)

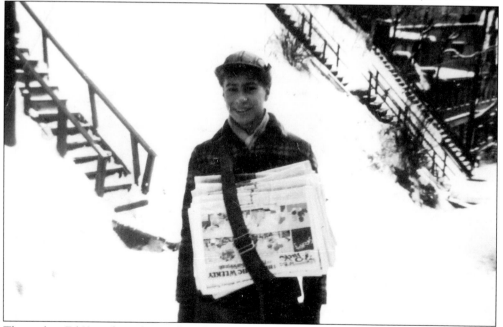

The author Ed Yanosko is featured in this photograph from the 1940s. The location is Gershon Street, up above the East Street Valley. Notice the steep steps that were common to the area. This was obviously not a route that could be completed on a bicycle. (Edward W. Yanosko.)

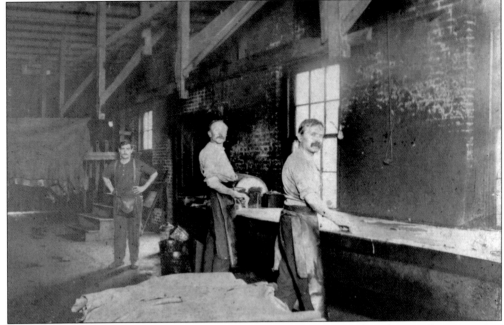

Frank William Brittner Sr. is pictured on the left in this photograph, taken in the tannery of Wettach and Co. where he was the foreman. The photograph was taken around 1915. Wettach and Co. was in operation from 1880 until 1916. Oswald & Hess operated a meat-processing facility there for years after the tannery went out of business. (Bernie Brittner.)

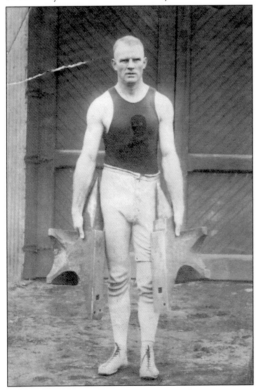

It is hard to imagine the arm strength needed to grip an anvil in each hand, but the tough-looking wool puller in this undated photograph makes it look easy. During one of the initial stages of the tanning process, the hides would be placed in a huge vat filled with icy water and sodium sulfite. The workers would have to reach in up to their shoulders all the while getting cut by horns, bones, and hoofs. They would not bleed until they sat down to take a break at lunch when their frozen arms would thaw. (Jeff Kumer.)

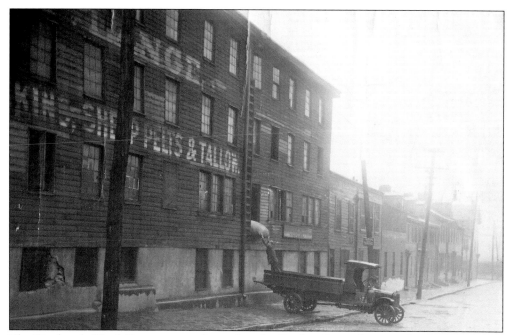

The Pittsburgh Wool Company was located at the Pindam Street location from 1912 to 1958. This 1929 photograph shows a bag of sacked wool being lowered onto a truck. The building had been used as a tannery since 1871. The boom period for the tanning industry in the Pittsburgh region was between 1850 and 1900. (Jeff Kumer.)

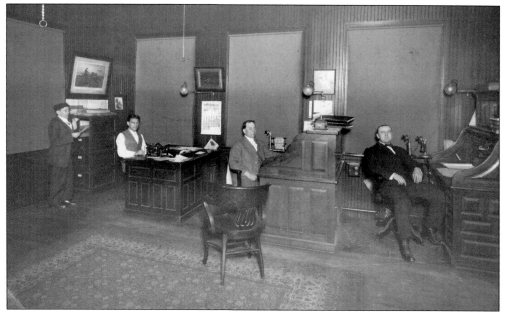

William P. Lange (center) and Charles B. Kumer (far right) are pictured in the Pindam Street office of the W.P. Lange Tannery. This photograph was taken in 1907. The Pittsburgh Wool Company incorporated in 1912. Lange was the principal owner until the 1940s, when the Kumers took control. The Pittsburgh Wool Company was the last operational pullery in the United States. (Jeff Kumer.)

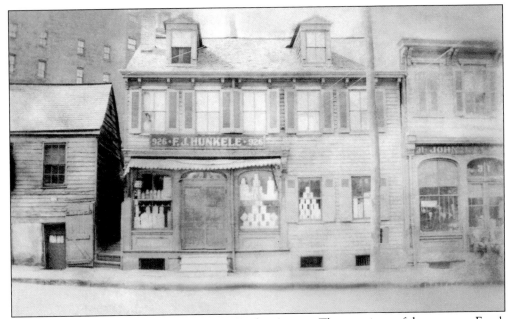

This general store was located at 926 Spring Garden Avenue. The proprietor of the store was Frank J. Hunkele. He owned and operated the store from the 1890s up to the 1940s. Notice the Lutz & Walz Allegheny Brewery behind the store. The customers who frequented this establishment worked as bakers, brewers, butchers, and bottlers in the surrounding neighborhood. (Ted Hunkele Jr.)

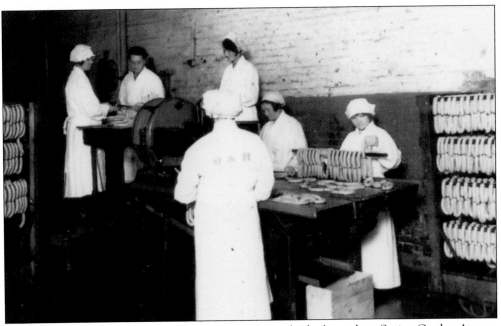

The Oswald & Hess meatpacking company moved into the facilities along Spring Garden Avenue when Fried & Reineman Packing Company moved its operations to East Ohio Street in 1923. The women in this undated photograph are making sausages. (Bernie Brittner.)

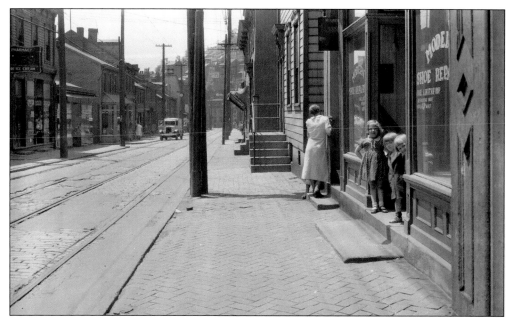

The Modern Shoe Repair establishment was located on Spring Garden Avenue. This photograph was taken on May 31, 1935. It was the middle of the Great Depression, and people very much needed to figure out ways to make things last longer. When a pair of shoes or boots got too worn, they would be taken in for repairs. (Pittsburgh City Photographer, 1901–2000, AIS.1971.05, Archives Service Center, University of Pittsburgh.)

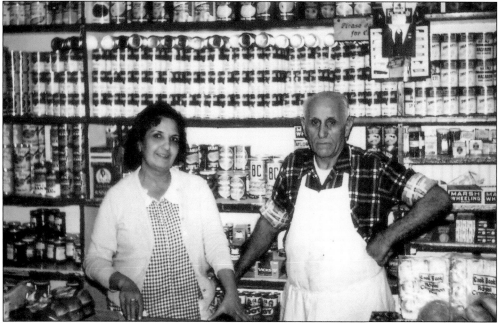

This general store was located at 1109 Goettman Street. It was owned and operated by Charlie and Philomena Coury. The Courys first owned a store on Troy Hill Road in the mid-1950s before relocating it to the Goettman Street address. They raised three daughters in the neighborhood, all of whom went to Most Holy Name. This photograph dates from the early 1970s. (Len Mielnicki.)

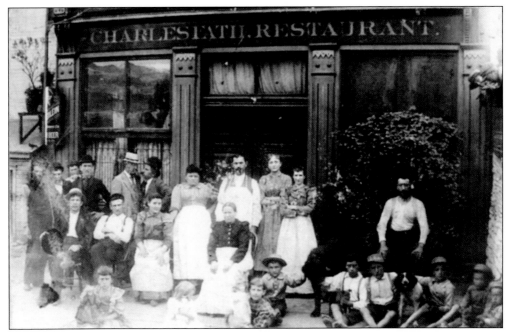

This 1898 photograph shows the proprietors and patrons of the Charles Fath Restaurant, which was located at the intersection of Luella and Main (Mina) Street in City View. At the time this photograph was taken, the streets in this neighborhood were dirt or mud, depending on the conditions, and the sidewalks were wood planks. (Edward W. Yanosko.)

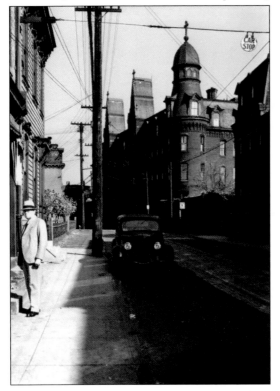

The Good Shepherd Home is the focal point of this photograph from the early 1940s, but many residents of the area will remember other landmarks not clearly seen. Dr. Heck's office was nearby, as was Schnebel's meat market, Arborgast's drug store and Rimondi's fruit store. Notice the "Car Stop" sign at the top, indicating where the street cars picked up and dropped off riders. Otto Schnebel is on the left. (Carnegie Library.)

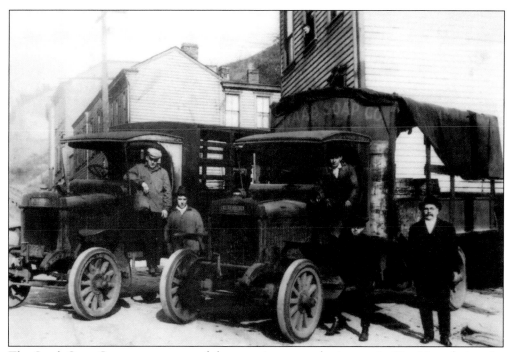

The Staab Soap Company was one of the most important businesses in City View during the early part of the 20th century. It was located on Royal and Bly Streets and Staab Way. Soap was a natural byproduct of the meat-processing industry. (Bernie Brittner.)

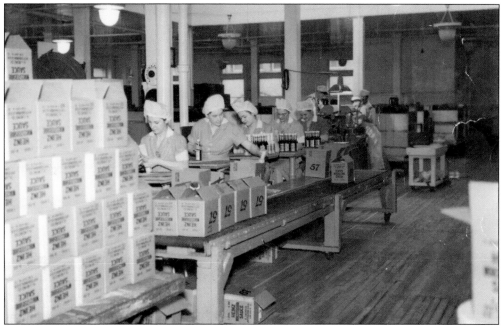

The decades of the 1940s and 1950s saw huge expansions in market share and in sales for the H.J. Heinz Company. New product lines were purchased, and new processing facilities were brought on line. Fewer and fewer products would ultimately end up being produced at the Pittsburgh facility. This undated picture shows women packing cases of Worcestershire sauce. (Len Mielnicki.)

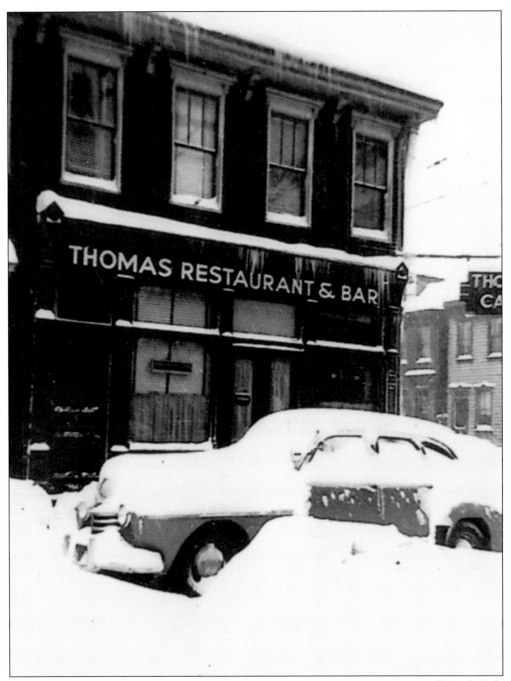

The Thomas Restaurant and Café was a popular eatery for several generations of North Side residents. During the day, the place was always busy. One of the things it was known for was its ham sandwich. Behind the bar, they always had a fully cooked ham on display and ready to be carved. The restaurant was also known for its potato pancakes. The bar entrance was on Madison Avenue, and the side entrance was on Tripoli Street. Their establishment was unfortunately in the pathway of Interstate 279. They were one of the last businesses to remain and did not shut their doors until 1978. (Bernie Brittner.)

Nine

OUT IN THE COUNTRY

Mary Duermeyer sits on the hood of the 1940s-era Chevrolet along Spring Garden Road. This section of the road is much removed from the former industrialized areas closer to the city where the tanneries were located. In 1951, when this photograph was taken, this section of road was very much considered to be out in the country. The kids in her family would pick violets and hunt for tadpoles and crayfish, while her father would use the creek water to wash the car. (Mary Dzubinski.)

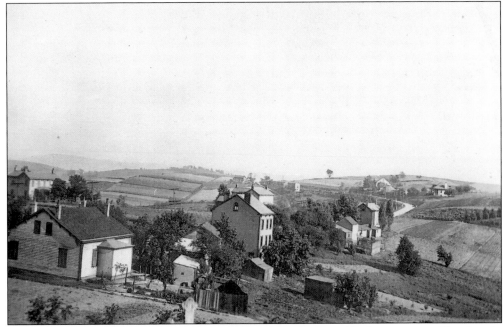

This 1915 photograph, taken from Most Holy Name Cemetery and looking in toward Pittsburgh, shows the picturesque rolling landscape that typified most of Reserve Township at the time. Farming was clearly the number one occupation for people who lived there. The Schneider's Farm is just out of sight on the left. (Frank Yochum.)

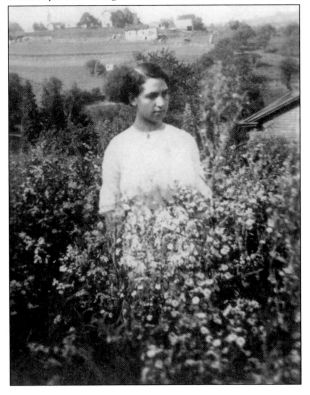

Katharine Simon is pictured in this pastoral setting from the early part of the 20th century. Her family grew produce to sell in the Pittsburgh market, as did most of her neighbors. Their house was located on Mount Troy Road. In the background, Schneider's Farm is plainly visible. (Frank Yochum.)

This old woman could have just as easily been photographed in some rural setting in some European country. Instead, she was filmed in Mount Troy. Magdalena Simon is the woman seen in her backyard tending her garden. The local kids' nickname for her was loosely pronounced, *"Schmierkase."* She was known as the "Cottage Cheese Lady" because she was always making cottage cheese. (Frank Yochum.)

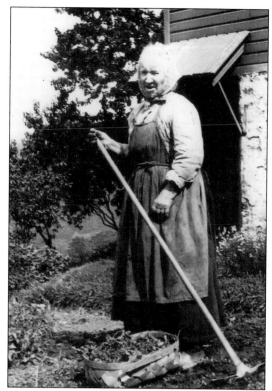

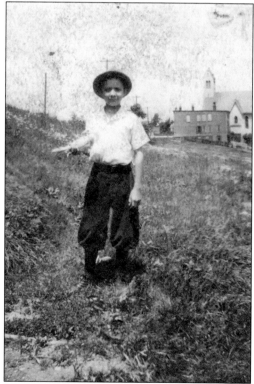

This photograph was taken on Schneider's property along Mount Troy Road. St. Aloysius Church in the background has the exterior appearance of the post-1919 renovations. Notice the pigeon in the boy's hand. Keeping pigeons was a popular pastime during the early part of the 20th century, especially in rural areas. (Frank Yochum.)

Mary Simon from Spring Garden is situated on a Schwinn Excelsior 7-C motorcycle in this photograph from the 1920s. The Excelsior brand was once a big-time player in the motorcycle world of this era, often ranking just behind Harley Davidson and Indian. It is unknown whether she was just posing on the motorcycle or whether she rode it. It was rare but not unheard of for women during the 1920s to ride motorcycles. (Frank Yochum.)

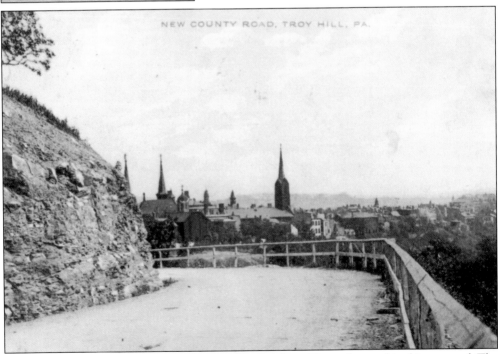

The new county road that connected Troy Hill with Mount Troy is featured in this postcard. The three-acre Scriba property was situated on top of the hill on the left. Visible in the distance are the steeples of Most Holy Name, the cupola from Most Holy Name School, and St. Anthony's Chapel, including the old dome from the original chapel structure. (Marlene Dickson.)

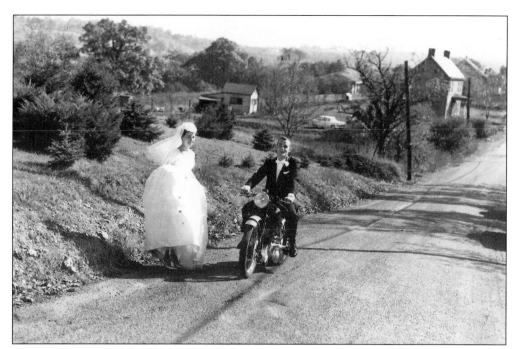

The WLA was a model of Harley-Davidson motorcycle that was produced to US Army specifications in the years around World War II. After the war, America was flooded with these army surplus motorcycles. They were sold as-is and in drums full of oil to keep the parts secure and free of rust. This photograph of an unknown bride and groom was taken on a Reserve Township dirt road around 1947. (Dan Kablack.)

Lena Hunkele and her daughters Bertha (left) and Coletta seem to be enjoying the afternoon sun in their garden behind their Spring Garden Avenue home. Even though indoor plumbing started appearing as early as the 1870s in many of the more prosperous neighborhoods of Allegheny City, many residents still used an outhouse decades later. This photograph was taken in 1916. (Pat DiGiovine.)

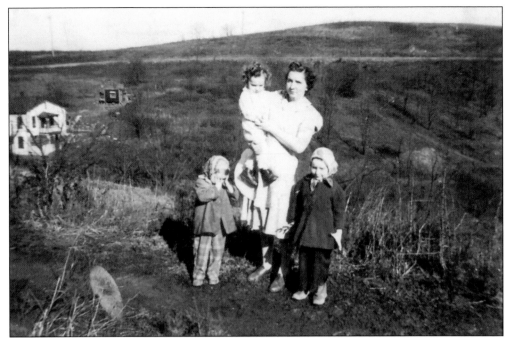

Madeline Hunkele is shown holding her son Ted Hunkele Jr. in this photograph from around 1946. The photograph was taken by Ted Hunkele Sr. at their East Beckert residence. Madeline's daughters Carol (left) and Mary stand on each side of her. The road in the background is Pittview Avenue. (Ted Hunkeke Jr.)

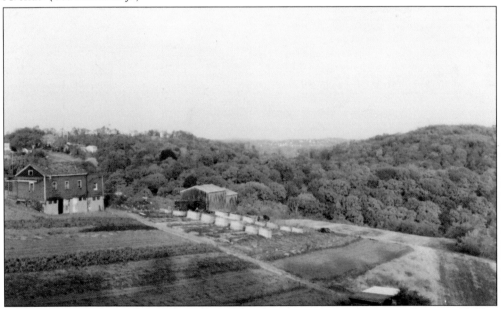

Drivers heading north on Mount Troy Road away from the city will undoubtedly recognize this scene that develops outside of their passenger window. Just after cresting the hill and passing Ridgelawn Cemetery on the left, the whole valley on the right opens up and Schneider's Farm pops into view on the right. The farm, as seen in this 1982 photograph, looks pretty much the same way as it has for the past 100 years. (Frank Yochum.)

Ten

LOOKING AHEAD

The 2007 addition of Sarah Heinz House that the new swimming pool is located in is pictured on the far right in this photograph. Gone is the old East Ohio Street and its many businesses. In its place is the Route 28 interchange, designed to move large numbers of cars through the area. (James W. Yanosko.)

Over 700 different sets of steps are maintained by the City of Pittsburgh. Many of these steps evolved from Indian trails to wooden planks to concrete structures with metal railings. When most of the neighborhoods were laid out, walking was a primary mode of transportation. Many of these steps were drawn out as roads on city maps and to this day remain that way often befuddling out-of-town drivers trying to navigate through a tight urban setting. This set runs from Bohemian Hill down to Vinial Street and affords an excellent view of the city. (James W. Yanosko.)

The Dirty Dozen is a bicycle race up the 13 steepest hills in the city that is organized by two-time former Race Across America (RAAM) champion Danny Chew. Riders proceed in a group to the base of each hill and then sprint up. Pig Hill is one of the featured climbs of the race. Pictured in the background in this photograph is the Louis Reinemann mansion, located at the intersection of Ley and Rialto Streets. (Edward W. Yanosko.)

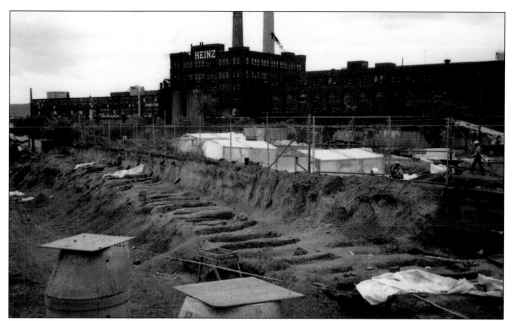

In 1987, when excavation for Interstate 279 reached the site of the former Voegtly Church, a small gravesite was discovered. As technicians and archeologists worked, their discovery grew in scope. Eventually, 724 features thought to represent 19th-century burials were identified. This long forgotten cemetery had faded from memory in large part because of the expansion to a new off-site cemetery up on Troy Hill in 1861. (Edward W. Yanosko.)

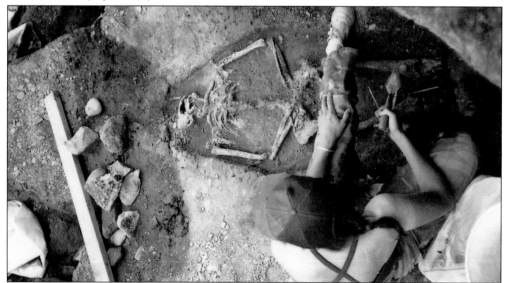

Several of the remains discovered were taken to the Smithsonian Institute for thorough analysis. Eventually, the remains were reinterred at the Voegtly Cemetery on Troy Hill. The marker there reads: "This burial plot contains the exhumed remains of members of the former Voegtly Evangelical Lutheran Church. The unmarked burials dating from 1823 to 1860 were exhumed May–September 1987 from the churchyard located at the corner of East Ohio Street and Ahler's Way in the city of Pittsburgh's Northside. The burials were reinterred by the Commonwealth of Pennsylvania October 2002." (Edward W. Yanosko.)

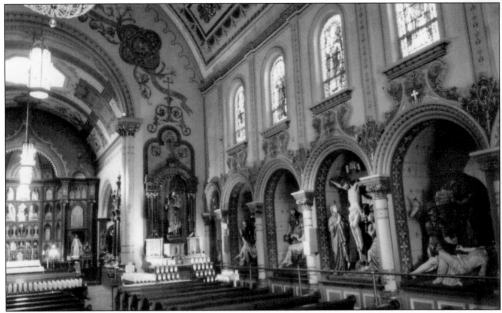

The addition of the chapel was completed in 1892, which was 12 years after the initial structure was dedicated. The purpose of the addition was to house the life-sized figures of the Way of the Cross. To this day, these masterpieces are the chief attraction at St. Anthony's Chapel. They were made at the Mayerischen Kunstaustallt in the 1880s and imported from Munich, Germany. The stations sat in crates on the lot beside the chapel for two years during the construction period before they were finally placed in their permanent home. (Edward W. Yanosko.)

This early 1980s photograph shows how the intersection of Troy Hill Road and East Ohio Street looked just prior to the drastic changes that took place for the construction of Interstate 279. Notice the old E&O Brewery and how it looked prior to the restoration. (Edward W. Yanosko.)

Across from Heinz House stood the old Voegtly Church, which is shown this mid-1980s photograph. In the distance can be seen St. Mary's Church, but other than that, most of the other buildings are gone, including Three Rivers Stadium. St. Mary's Church is currently known as the Great Hall and is part of the Priory Complex. The Priory was originally constructed in 1888 and served as a home for resident Benedictine priests and brothers. It is currently in operation as an exclusive 24-room, European-style hotel. (Edward W. Yanosko.)

The Heinz Complex is made up of residential lofts, office space, and the Sarah Heinz House Recreation Facility. It has been transformed from a gritty industrial neighborhood to an attractive community center located just minutes from the heart of the city of Pittsburgh, as well as the main attractions on the North Shore. (James W. Yanosko.)

The close proximity to Pittsburgh, as well as to Allegheny City, is what made these neighborhoods such vibrant communities in the 19th century. At the dawn of the 21st century, these areas are poised for a rebirth as a new generation discovers the convenience of urban living. (James W. Yanosko.)

BIBLIOGRAPHY

Allegheny City Society, The. *Allegheny City 1840–1907.* Charleston, SC: Arcadia Publishing, 2007.

Allegheny County, Pennsylvania, Illustrated. Pittsburgh, PA: Consolidated Illustrating Company, 1896.

American Street Railway Investments. NY: The Street Railway Publishing Company, 1898.

Eberhardt and Ober Brewing Company Records, 1882–1906.

Fleming, George Thornton and the American Historical Society. *The History of Pittsburgh and Environs.* New York and Chicago: 1922.

Canning, John. *Along the Towpath and the River Road.* Pittsburgh, PA: Allegheny City Society, 2000.

————. *Heimat in Allegheny.* Pittsburgh, PA: Allegheny City Society and Troy Hill Citizens, 1999.

Grace Lutheran Church 90th Anniversary 1893–1983. PA: 1983.

Most Holy Name 60th Anniversary Program. PA: 1928.

Most Holy Name 100th Anniversary Program. PA: 1968.

Rotenstein, David S. "Leather Bound: Nineteenth-Century Leather Tanners in Allegheny City." *Pittsburgh History* 80 (Spring 1997): 32–48.

St. Aloysius Church Centennial 1882–1992. PA: 1992.

St. Ambrose Centennial 1894–1994. PA: 1994.

St. Anthony's Chapel Committee. *St. Anthony's Chapel.* Pittsburgh, PA: J. Pohl Associates, 1997.

St. Boniface School 1884–1972. PA: 1972.

St. Nicholas 100th Anniversary 1894–1994. PA: 1994.

Teutonia Mannerchor. *Teutonia Mannerchor 1854–2004.* Pittsburgh, PA: 2004.

DISCOVER THOUSANDS OF LOCAL HISTORY BOOKS FEATURING MILLIONS OF VINTAGE IMAGES

Arcadia Publishing, the leading local history publisher in the United States, is committed to making history accessible and meaningful through publishing books that celebrate and preserve the heritage of America's people and places.

Find more books like this at
www.arcadiapublishing.com

Search for your hometown history, your old stomping grounds, and even your favorite sports team.

Consistent with our mission to preserve history on a local level, this book was printed in South Carolina on American-made paper and manufactured entirely in the United States. Products carrying the accredited Forest Stewardship Council (FSC) label are printed on 100 percent FSC-certified paper.

MADE IN THE